FRITZ EICHENBERG
WORKS OF MERCY

THE CATHOLIC WORKER

Vol. XXVIII No. 10 MAY, 1962 Subscription: 25c Per Year Price 1c

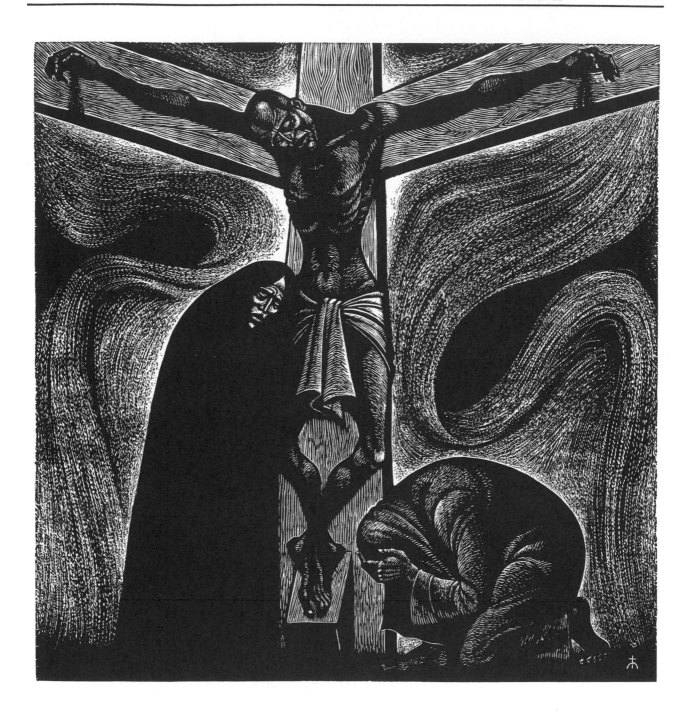

FRITZ EICHENBERG

—

WORKS OF MERCY

EDITED BY ROBERT ELLSBERG

ORBIS BOOKS

Frontispiece: BLACK CRUCIFIXION (*1963*)

Second Printing, February 1993

The Catholic Foreign Mission Society of America (Maryknoll) recruits and trains people for overseas missionary service. Through Orbis Books, Maryknoll aims to foster the international dialogue that is essential to mission. The books published, however, reflect the opinions of their authors and are not meant to represent the official position of the society.

Copyright © 1992 by the Estate of Fritz Eichenberg
Published by Orbis Books, Maryknoll, NY 10545
Manufactured in the United States of America

Library of Congress Cataloging-in-Publication Data

Eichenberg, Fritz, 1901–90
 Works of mercy : the Catholic worker / Fritz Eichenberg : edited
by Robert Ellsberg.
 p. cm.
 ISBN 0-88344-828-9
 1. Eichenberg, Fritz, 1901–90. 2. Bible—Illustrations.
3. Jesus Christ—Art. 4. Christian saints in art. [1. Catholic
worker—Illustrations.] I. Ellsberg, Robert, 1955-
II. Catholic worker. III. Title.
NE1112.E32A4 1992
769.92—dc20 92-17041
 CIP

I would like to think that through my work as an artist and through my personal relations I have been able to make friends all over the world.

I am grateful for the fact that I was given the talents of an image maker, enabling me to interpret the great classics as well as expressing my own thoughts, and that I was allowed to pass on my experiences to generations of young artists.

It is my hope that in a small way I have been able to contribute to peace through compassion and also to the recognition, as George Fox has said three centuries ago, "that there is that of God in everyone", a conception of the sanctity of human life which precludes all wars & violence.

Fritz Eichenberg

Contents

Preface

by Robert Ellsberg

The title of this volume, *Works of Mercy*, evokes the words of Jesus in Matthew 25. There he indicated his enduring and real presence, not only in bread and wine, but in the needs of the stranger and the occasion for solidarity: "I was hungry and you gave me food. . . . " The corporal works of mercy are to feed the hungry, give drink to the thirsty, clothe the naked, ransom the captive, shelter the homeless, visit the sick, and bury the dead. As interpreted by Dorothy Day, these injunctions became the inspiration for the Catholic Worker movement, an effort to realize the radical implications of the Gospel.

As the title of this collection of art by Fritz Eichenberg, *Works of Mercy* also refers to the artist's forty-year association with the Catholic Worker movement and newspaper, in which nearly all of these drawings and wood engravings originally appeared. Many of them are direct meditations on the words of Christ: "Inasmuch as you did these things to the least of my brothers and sisters, you did them to me." To the extent that these images inspire the compassion they depict, to the extent that they strike a blow against the forces of dehumanization, then works of art assume the power of deeds. These too are truly "works of mercy."

Fritz Eichenberg, who died in 1990 at the age of 89, was widely acknowledged as one of the modern masters of the wood engraving. A German refugee and Quaker convert, he achieved renown in this country for his illustrations of such literary classics as *Crime and Punishment*, *Wuthering Heights*, and *Gulliver's Travels*. His work is featured in galleries and museums around the world.

But through his association with *The Catholic Worker* he achieved recognition among a different audience. His wood engravings could be found printed on fading newsprint, taped to the walls of a coal miner's home in West Virginia or a farmworker's shack in California. In over a hundred works, some reprinted so often as to assume the status of Catholic Worker icons, he was able to summarize in simple images the moral and spiritual perspective which the editors otherwise strove to communicate in words and deeds.

The present volume does not pretend to offer anything close to a comprehensive retrospective of Eichenberg's work—most of which is represented in his literally thousands

of literary illustrations. Rather, *Works of Mercy* collects the most popular and enduring examples of his Catholic Worker art. It was in this body of work, offered as a gift to the Catholic Worker and to Dorothy Day, whom he loved and revered, that Eichenberg achieved the synthesis of artistic vision, social conscience, and nondogmatic faith that epitomized his own personal stance.

The accompanying texts which appear in this book reflect the intimacy between word and image which so characterized Eichenberg's career. In this case, however, the roles are reversed: it is the written texts, mostly drawn from *The Catholic Worker*, which serve to illustrate the visual text, the drawings and wood engravings themselves. Of course, Eichenberg was always an interpreter—not just an illustrator. He sought to reveal the inner truth of the characters he depicted, whether the distorted genius of Raskolnikov or the frustrated passion of Heathcliff. Similarly, in his reflections on the life of Christ or the daily life of the Catholic Worker community, he tried to depict reality in terms of its full depth as an opening to mystery and grace.

A special word of gratitude is due to Toni Eichenberg, Fritz's wife, who designed this volume, and without whose loving commitment it would not have been possible.

I came to know Fritz Eichenberg during my own years at the Catholic Worker. Fritz was attracted to the idealism and high principles of youth, and reached out to me and others with grandfatherly affection. Solitary and ascetic in his craft, acutely sensitive to the beauty and suffering of the world, he was always immensely grateful for the love and understanding of his friends. Fritz, in his modesty, considered his own contributions to be relatively minor compared to the heroic feats of those who lived among the destitute or went to prison in pursuit of peace. For my own part, I never met his equal for integrity, generosity, and largeness of soul. Truly, he showed that every witness to the truth, whether great or small, every act of hope, every work of mercy leads inevitably to the source of Mercy.

Fritz Eichenberg: Artist of the Peaceable Kingdom

by Jim Forest

It was my eye rather than ideas that first drew my attention to *The Catholic Worker.* I was attracted by the paper's black-and-white illustrations. One of the artists was Ade Bethune, who had designed the Catholic Worker symbol and provided many other lino cuts. The other artist was Fritz Eichenberg, who later became a friend. Their images inspired me to read the paper.

With its advocacy of community, hospitality, voluntary poverty and nonviolence, and its dedication to a vital liturgical life, *The Catholic Worker* turned out to be the most interesting and challenging publication I had ever held in my hands, providing a month-by-month commentary on what it was like trying to live the Gospels in a brutal, money-centered social order. It was also impressive for its devotion to a life centered in the sacraments and its commitment to the Catholic Church. Not that the editors were unaware of the Church's shortcomings; far from it, but—like Saint Francis of Assisi—they hoped to live in such a way that it would be more likely that the hierarchy could offer an uncompromised witness to the Gospel. *The Catholic Worker* starting point, however, wasn't what the bishops should do but what each of us should do. The big question was: "How can *I* follow Jesus?"

The answers one found in the newspaper's columns were not rigid ("we have no party line" was something of a Catholic Worker slogan) but opened up a range of possibilities linked not by rules but by values. Far from being a paper dispatched from an ideological ivory tower, *The Catholic Worker* mainly reported what the editors themselves were doing, whether living with people who previously had no home, or setting up rural communities for the casualties of urban industrial life, or going to prison for acts of civil disobedience protesting racism and war.

At the heart of it all was a remarkable woman named Dorothy Day, a convert to Catholicism who, urged on by a French immigrant named Peter Maurin, had founded the paper in 1933. In her early years she had been drawn to the political left. Her love of novels and poetry, of classical music and fine art, had been factors in her attraction to religion in general and Catholicism in particular, though even more decisive was her desire to be part of a Church that was so much

In the beginning was the Image

FRITZ EICHENBERG

The world will be saved by beauty

FYODOR DOSTOYEVSKY

a home to the poor. The final event that pushed her across the border from admiration to conversion was the birth of her daughter, Tamar, in 1927. Wanting the best for her daughter, Dorothy wanted Tamar baptized. (In contrast with Dorothy's views, Tamar's father, an ardent anarchist, would have nothing to do with civil or ecclesiastical structures. Their diverging attitudes toward Christianity finally brought their common-law marriage to an end.) Tamar, still an infant, led Dorothy into Catholicism.

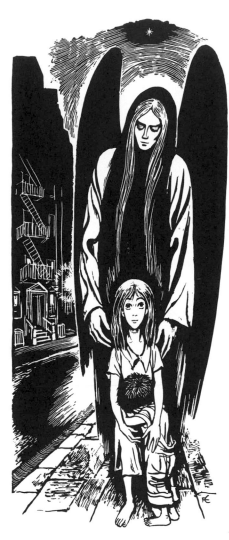

At the time I picked up my first copy of *The Catholic Worker*—it was in 1960 while I was in the Navy—Dorothy Day's name meant nothing to me. I was less interested in the articles than the art. One of the illustrations, a wood engraving by Fritz Eichenberg of the Peaceable Kingdom, impressed me deeply, as did one of his many depictions of St. Francis.

I had no idea at the time how remarkable it was that Fritz Eichenberg should be associated with such a periodical. Far from being Catholic, his aversion to dogma and institutional structures had led him to become a Quaker. But other factors—most of all his admiration for Dorothy Day and the love of Dostoyevsky they shared—had drawn him to the Catholic Worker movement and a role in its newspaper. As I came to discover, his life had well prepared him for such a collaboration.

Fritz was born in 1901. His parents were of Jewish background. "I grew up with the same mistake as all assimilated Jews in Germany," he later noted, "thinking we were German." His father, ill through much of his childhood, died of Parkinson's disease when Fritz was fourteen.

One of his teachers was the city of his birth, "the most Catholic city of Cologne, one great picture book, with its ancient wood carvings of saints and sinners and its heritage of painters and carvers." Fritz regarded his lifelong passion for engraving images into wood as Cologne's chief gift to him. He experienced the city as a midwife of artistic vocations. Just to live there was to receive a free education in the arts. He grieved for the city's destruction in the Second World War.

His home also tilted him toward the arts. His parents loved music and his two sisters played the piano. "Our house was

filled with music," he said. "Bach and Beethoven, Mozart and Schumann revived us daily."

Fritz's conscience was shaped in part by his innate distaste for militarism. At his "very Prussian, militaristic" school, the students were treated "like little soldiers." Art in all its forms was regarded as unmanly. Non-German literature was ignored. Beatings and whippings were common events. Here he learned "how brutalization kills understanding, between countries, between people, within families." At the age of five or six he was one among the thousands of school children waving little flags as the Emperor entered the city. "We were raised to think consciously of the Emperor as a divine person." The poetry and songs students learned were for the glorification of empire and war. "The Lord protected me from wanting to be a part of all that. I hated regimentation."

Just beginning his teens when the First World War began, Fritz quickly learned the difference between propaganda and reality, receiving the lesson that the great victor is not one side or the other but death itself. Yet the malnourishment brought by the war played a providential role in his life. He fainted from hunger one day in front of a door that happened to belong to the home of Fritz Witte, priest, art historian and curator of the Museum of Religious Art. Dr. Witte found Fritz and brought him inside. "When I woke up he asked me a few thoughtful questions about my future plans and ambitions, and pulled out of his library two volumes of Eduard Fuch's *History of European Satirical Art*. They became my Bible." Here he encountered Bosch, Hogarth, Goya, Daumier and others whose socially-responsive art deeply influenced his vocation. "Those two volumes fortified my resolve to be a witness to my time."

Reading also played a crucial part in the shaping of his soul. "Dostoyevsky, Tolstoy, Gorky, Dickens and Kafka were always at the top of my list and shaped my young mind. They . . . made me aware of how universal the suffering of mankind is, especially for the poor and the oppressed and made me conscious of the power of love, and of the agonies and elation of a creative life."

Fritz began attending evening art classes and spent countless hours sketching animals at the Cologne Zoo among caged creatures who in some ways were freer than their

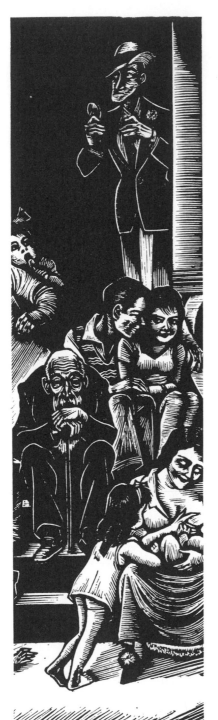

human admirers. They were not required to be patriotic. "It was the first zoo in the world without bars," Fritz said appreciatively.

With the war's end in 1918, Fritz became an apprentice in a print shop in Cologne, rubbing ink on lithographer's stone and drawing wine labels. "It was then that I really began to live," he said a half-century later. "The war had finally ended. Like most people, I was hungry, half-starved really, happy to get a single piece of black bread and one thin herring. Yet I was unbelievably happy. I was finally doing what I wanted to do." A year later, he was accepted as a master student at the Academy of Graphic Arts in Leipzig.

Always in love with books and longing to illustrate them, Fritz's first published wood engravings appeared in 1922, accompanying Charles de Coster's *Till Eulenspiegel*. In the same period he did a set of lithographs for Dostoyevsky's *Crime and Punishment*, the beginning of what was to be a lifelong fascination with the Russian classics.

In 1923 he married and the same year moved to Berlin where he worked as a roving artist-reporter and drew political cartoons. Hitler was a frequent target of Fritz's pen.

"When it was clear that Hitler was going to run the country, I decided that I had better make my home somewhere else — I smelled a rat and wanted to breathe sweeter air. I left Germany in 1933, practically the day when Hitler became chancellor, going first to Guatemala and Mexico. My idols then were Rivera and Orozco, artists of social conscience. It didn't take me long to make my way north, entering the United States through Texas and going on to New York. This seemed the place to live so I returned to Germany to get my wife and our baby. Luckily the police paid no attention to us — they had bigger fish to fry at that moment." Later he was able to get other family members safely out of Germany.

"We sailed to New York. What a city it was, and such a wonderful country! I was able to make $22.75 a week working for Roosevelt's WPA, doing any sort of art work I wanted to. I made my first wood engravings of Saint Francis of Assisi at that time, though I hadn't yet become aware of Dorothy Day and the Catholic Worker community, the place Saint Francis would have been in New York." (It was May first of that year that the first issue of *The Catholic Worker* was published, a

small tabloid handed out free on Union Square. Within a few months the first Catholic Worker house of hospitality was taking root.)

In 1936 Fritz was again illustrating books. Some were cited by the American Institute of Graphic Arts. Then the first commission came from the Limited Editions Club to illustrate Dostoyevsky's *Crime and Punishment*, a second opportunity to illustrate his favorite book. The results remain among Fritz's finest achievements. I know Russians who are astonished that a non-Russian artist, even a man who had never set foot in Russia, could see so deeply and truly into the Russian soul and into the iconography of the Orthodox Church.

In 1937 his wife died. "I had a breakdown. Thank God friends helped me and my little daughter. Home became the basement of a friend's house. Thanks to them, we survived. Another friend got me interested in Zen Buddhism, which was the beginning of my apprenticeship with silence. Through Buddhists I discovered Quakers." In 1940, after extended reflection, Fritz became a Quaker. "I have never been without my criticisms of Quakerism," he said. "I find Quakers in general too polite, too genteel! I think they would rather have the American Friends Service Committee respond to crisis than respond themselves. Also, in contrast to the Catholic Church, Quakers have little understanding or appreciation of art. But all things considered, it was what fit me best."

His edition of Jonathan Swift's *Gulliver's Travels* was published in 1940 and the next year Turgenev's *Fathers and Sons*, followed by Charlotte Bronte's *Jane Eyre*. Book commissions were constant for the rest of his working life. (An autobiographical review with many of his book illustrations was published in 1977: *The Wood and the Graver*. His massive study of print-making and techniques, *The Art of the Print*, was published by Abrams in 1974.) In 1947 he began many years of teaching at the Pratt Institute and the University of Rhode Island.

Soon after, there occurred one of the major events in Fritz's life: his meeting Dorothy Day in 1949. The encounter was occasioned by their attending a conference on Religion and Publishing at Pendle Hill, a Quaker conference center at Wal-

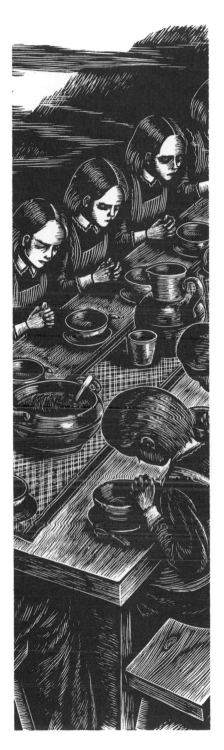

lingford, west of Philadelphia. Fritz's awareness that Dorothy would be there was a factor in his decision to take part. Gilbert Kilpack, Pendle Hill's Director of Studies and an inspired matchmaker, arranged for them to sit next to each other. A friendship quickly took root that was to last the rest of their lives.

"Dorothy loved Dostoyevsky and knew me for my illustrations for *Crime and Punishment* and *The Brothers Karamazov*," Fritz recalled. "I think she shared with Dostoyevsky the conviction that beauty will save the world. She had such an intense love of beauty, for art of every kind. It was deeply embedded in her. For me this was one of her most striking qualities.

"She asked if I would work for *The Catholic Worker* even though she had no money to pay me. She wanted something that would express without words the spirit of the Catholic Worker movement, especially to people who couldn't read. I was so pleased to be asked! Through Dorothy, a period of my life began in which I was able to contribute to the work of a movement that gives an example of the spirit of poverty and unconditional love and nonviolence. These are things Quakers aspire to but the Catholic Worker practices. Also I was drawn to the Christ-centeredness of the Catholic Worker, the way that they saw Christ in everyone. If you see Christ in every living being, how can you kill? It's impossible. The Catholic Worker, for me, is not only a way of seeing but of listening, listening so carefully that the person you listen to may be changed for the better, even a very violent person."

Visiting the Catholic Worker house of hospitality in New York a week after this first meeting, Fritz met people who had practically nothing, whose lives were full of tragedy, and yet whose gifts sometimes came to light in the special environment of the Catholic Worker. One visit led to another. Fritz quickly became part of the Catholic Worker family, contributing not only his art but his voice to the community, giving occasional talks at the CW's Friday night meetings. Many still remember the slide talk he presented several times, "The Drama of the Human Face." "Everything is written in the human face," he often commented.

"I owe so much to Dorothy," Fritz cheerfully admitted. "Meeting her was the kind of chance encounter that changes

one's life. Because of her my work as an artist had a new zeal. She helped me in so many ways. She felt the great sadness in me, which is the lot of most artists, and helped me to ease it by reassuring me of the value of what I was doing—away from the activist's battles, the demonstrations, the jails, and the physical abuse—and yet contributing my share through the gifts the Lord gave me, though sitting at my work table in comparative peace and comfort."

In the years that followed his meeting of Dorothy, Fritz produced a steady succession of drawings and wood engravings for *The Catholic Worker*, over a hundred altogether: portraits of saints and heroes as well as biblical scenes and panoramas from the Old Testament and the Gospels, often with a contemporary Catholic Worker setting.

"In the beginning," Fritz recalled in an interview with Nancy Roberts, "I was rather timid because I was in unexplored territory. The Catholic religion to me was kind of archaic." If it had been any other Catholic publication asking for his help, it's unlikely he would have agreed. But Dorothy Day was someone he couldn't resist. "I found in Dorothy a person who could combine the gentleness of the Christian faith with her very aggressive attitude toward everyday life and what's going on in the world. She didn't mince words."

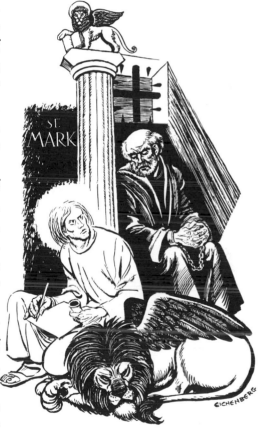

Dorothy's first request to Fritz was to make illustrations of some of her favorite saints starting with Vincent de Paul and St. Anthony. "Anything you can do with these saints we'll take," she assured him. "She gave me a book of saints and I began to study them. Dorothy was delighted with the results. From that time on my work was in practically every issue."

Among the other illustrations of saints Fritz provided over the years were Mary, Joseph, Peter, Benedict, Francis of Assisi, Dominic, John of the Cross, Martin de Porres, and even Joan of Arc.

It was a surprise to many that Dorothy was so devoted to Joan of Arc, a saint usually depicted wearing armor. But for Dorothy the central witness of the saint was in her fidelity to conscience, preferring death by fire rather than a life purchased with lies and compromises. In Fritz's portrait of Joan, she is seen not as a warrior but as a shepherd listening in rapture to the voice of an angel.

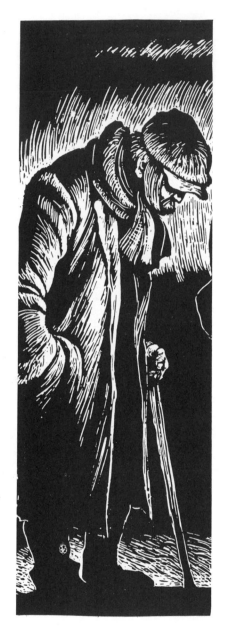

Mary was drawn in a variety of traditional settings, from the Annunciation to the Pietà, holding her son's body at the foot of the Cross.

Fritz did at least two Annunciations for *The Catholic Worker*. One stresses Mary's absolute absorption in the message brought to her by the archangel Gabriel. Mary's quiet face is tilted upward in wholehearted assent. Her body will become a house of hospitality for the Son of God. Fritz uses the traditional details of ancient iconography: she has opened the book through which the Word will enter the world, while the lilies in the vase prefigure the Resurrection.

His other Annunciation, first published on the cover for Dorothy's autobiography, *The Long Loneliness*, is more somber. Mary holds a belly that already suggests pregnancy as the archangel whispers in her ear. From the place where her feet touch the earth, a path leads toward three black crosses under a dark sky. Rays pass through the angel linking Mary with a radiant dove, symbol of the Holy Spirit. Mary's face suggests pre-knowledge of the Way of the Cross.

In one of his drawings of the Holy Family, Joseph, Mary, and the child Jesus are shown as homeless refugees on a barren road. One senses Joseph's exhaustion and near despair in a world in which rulers murder children. At the center of the panel is a barefoot Mary. While the Savior of the world sleeps in her arms, she looks up at the night sky with a look of dependence on God's mercy. It is her contemplative, prayerful attitude more than the halos that make us recognize her as the Mother of God. Fritz gives us a dramatic reminder that the world into which Christ was born, far from being a doll house village under a Christmas tree, was similar to our own with many fleeing for their lives.

One of his simpler Catholic Worker drawings shows Christ receiving his sentence, not from Pilate two thousand years ago but from a contemporary American judge who reads grimly from a paper without glancing up at those standing before him. "This was inspired," he said, "by going to the courthouse when Dorothy was sentenced for refusing to take shelter in an air raid drill in the early 1950s. It was heartbreaking to see her being treated like a criminal with no respect for her or what she was doing. On that occasion she got off rather lightly, two weeks at the Women's House of

Detention. But what I saw wasn't only Dorothy and other pacifists being sent to prison but Christ being condemned to death. And so I made that cartoon-like drawing."

Fritz engraved his "Black Crucifixion" in 1963 when civil rights workers were being killed. Terrible winds are howling around the cross on which Christ, a black man, has died while his black mother grieves. Again Fritz was moving Christ's life out of the unthreatening past, drawing lines of connection with the martyrs and tragedies of the present. There was a similar sense of inconsolable loss in the "Pietà" he engraved in 1955 during the Cold War's iciest period. A shrouded Mary rocks her son's dead body, her face paralyzed with sorrow.

A number of Fritz's *Catholic Worker* drawings and engravings honor some of those who were heroes to both Dorothy and himself, among them Erasmus, Tolstoy, Gandhi, Martin Buber, Cesar Chavez, Lanza del Vasto, Thomas Merton, and Catholic Worker co-founder Peter Maurin.

Erasmus was especially dear to Fritz. "Erasmus was a great humanist who spoke out on unpopular issues, a genuine rebel," Fritz wrote. "Erasmus fought the abuses of the Catholic Church, and he fought with Martin Luther at the same time. He remained with the Church and refused the cardinal's hat at the same time."

Among more elaborate pieces were ten wood engravings illustrating the Old Testament. His panels for the Creation and the Noah story show creation woven together while his study of the Fall is an image of disintegration, alienation, and deceit. His Job is shown as afflicted as much from his glib professorial friends as from any other malady. Jonah is a pilgrim finally brought to understanding the mercy of God as he sits beneath a vine. Jeremiah, in the most powerful of Fritz's studies of the prophets, is a grief-stricken survivor of war. The child hanging onto his chained arms seems to have found her way to Jeremiah's side from Auschwitz.

Several of Fritz's images have acquired the status of Catholic Worker icons. One finds them being re-used almost every year in *The Catholic Worker* and often reproduced in other publications. These especially reveal a vision which is at once his own and Dorothy Day's.

Of these the best known was among his first contributions to *The Catholic Worker*: "Christ of the Breadlines," an image

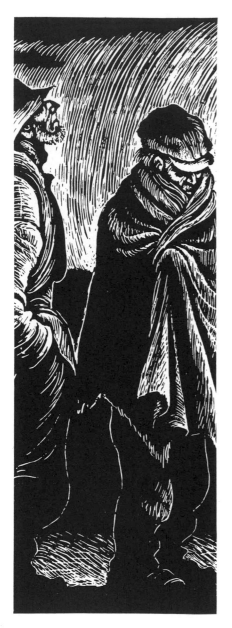

of down-and-out men and women in line, bundled up in ill-fitting clothing, nearly frostbitten from cold, waiting in a line that seems as frozen as they are. In the center, seen in silhouette, is Christ, the source of light and warmth in a dark and indifferent world that abandons so many. Christ, as powerless as those he is standing with, participates in their suffering. He is abandoned with them. The image is a vivid expression of Christ's words, "I was hungry . . . I was thirsty . . . I was homeless . . . I was naked . . . I was a stranger . . . I was a prisoner." This is the text which is at the heart of the Catholic Worker movement and which gave rise to its many houses of hospitality.

The people on line were similar to the people Fritz envisioned as his audience, "who might be," he explained, "not only people who can't read but who aren't familiar with the graphic arts, the kind of people you find waiting on lines for food or clothing or a place to sleep. More sophisticated people might dismiss this kind of work as naive but I hoped simple people wouldn't. Their opinion was the one that mattered most to me, as it did to Dorothy."

Another of his often reprinted illustrations, "The Lord's Supper," resembles both the Last Supper and the biblical scene of the resurrected Christ at Emmaus at the moment he is recognized in the breaking of bread. In Fritz's drawing Christ is among those eating bread and drinking coffee in a house of hospitality. The cold one felt in the "Christ of the Breadlines" gives way to familial warmth. Fritz connects the open door to the table, contrasting the unrelieved darkness outside with the light inside. While there is a suggestion of light around Christ's head to make clear who He is, Fritz seems to be saying with his simple composition that the circular table at which the homeless are made welcome is Christ's real halo. The picture says, "What you did for the least person, you did for me." Fritz's drawing is also an icon of the eucharist: Christ forever present in bread to those who remember him.

In "The Labor Cross," Fritz gathers images of people from several races at work—fisherman, farmer, woman caring for both children and sheep, carpenter, miner, and logger. The cross is shown as providing the context and basic architecture of daily life. The image confesses the burden of labor but still

more its glory. The panel affirms a fundamental value of the Catholic Worker, that human dignity is inseparable from work and that unemployment undermines the soul.

There is no theme that Fritz returned to so frequently in his work as "The Peaceable Kingdom," the one Catholic Worker icon with a Quaker source: the Peaceable Kingdom paintings by the eighteenth-century Quaker artist, Edward Hicks, who drew his inspiration, as did Fritz, from the section of Isaiah (2:2–4; 11:1–9) describing the "holy mountain" where community is restored between all creatures and killing of every kind is ended.

In one of these engravings all the subjects, human and animal, are joined in such a way that they are truly one. Together they form a face in profile, as if to say, "By refusing to kill, I can begin to live the peaceable kingdom here and now. It is not only a vision of a healed future but a way of seeing, hearing, and responding minute by minute."

In the most often reproduced of Fritz's Peaceable Kingdoms, a menagerie of animals are gathered around a child under a huge tree. Fritz's respect and love of the animal kingdom, dating back to his days sketching at the Cologne zoo, is apparent. A goat rests on a leopard's back while a lamb snuggles with a wolf. The lion's mane and the boy's hair mingle. In the distance to the left, under a dark, starless sky, is the city, place of non-welcome to both man and beast. To the right, a new moon shines in a clear sky. The sense of community is intense, a central value in the Catholic Worker movement with its wide diversity of personality types, ranging from lions to lambs.

Fritz's many works of St. Francis, with a diversity of animals attracted to the poor man of Assisi, who threatens no creature's life, belong to the Peaceable Kingdom series as do his engravings of Noah in peaceful company with all his guests on the Ark.

Whatever the theme, Fritz was able to provide illustrations that made the values and even the theology and spirituality of the Catholic Worker movement accessible to anyone, literate or illiterate, who had access to the paper. His contribution to *The Catholic Worker* was a participation in the kind of evangelical striving he celebrated on the opening page of his Pendle Hill booklet, *Art and Faith*: "The Fathers of the

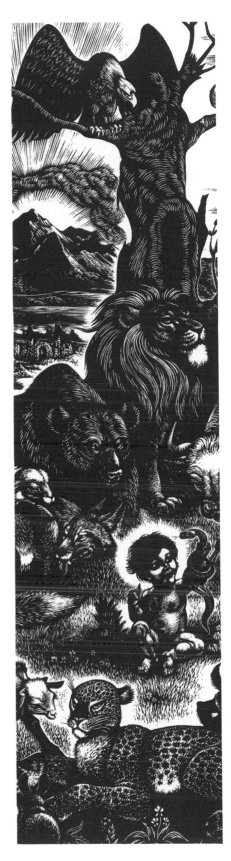

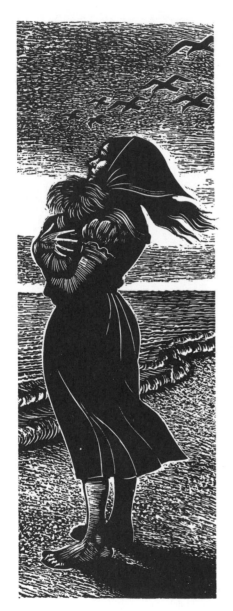

Early Church used the written word, the harmonies of sound, the graven image, in all their splendid forms to spread the Gospel across the Earth. In fact it is doubtful that without its vast iconography Christianity could have implanted itself so indelibly on the hearts and minds of men over such vast areas of time and space."

Without Fritz Eichenberg, the message Dorothy Day sought to communicate through *The Catholic Worker* would not have engraved itself upon so wide an audience.

Fritz took enormous satisfaction in the stories that reached him of his illustrations hanging on walls that hadn't seen new paint in many years. But the chief compensation for doing work for *The Catholic Worker* was the regular contact with Dorothy. "To see her laugh," he said, "was one of the great rewards of my life." He also rejoiced in her undisguised fondness for him. "Far from being formal with me, she would always embrace me and give me a kiss, right on the lips! This wasn't common in those days. People were more reserved. But if she liked someone, if she felt comfortable with a friend, she was completely free about showing it and not playing the part of a plaster saint."

She was also at times something of a confessor for Fritz. During a time of personal suffering in Fritz's life, Dorothy offered understanding and absolution. "Referring to Brecht's *Der Kreidekreis*, she asked me to draw a magic circle of chalk around me that would preserve my God-given identity, and sanity."

Dorothy died in 1980. "I miss her," he wrote me nearly three years after her death, "but feel very keenly and gratefully that she is around me and in me, eternally!"

His involvement with the Catholic Worker community and its publication continued unabated. He continued to accept invitations to speak at Catholic Worker Friday night meetings and enjoyed the affection that the young volunteers showered on him. "It was only after Dorothy died that one of my drawings was turned down—a drawing I did of Dorothy. I drew her as I remembered her earlier in her life. I think it was too different from the Dorothy they had known. By then her face had lost its mobility while the Dorothy I had known in the first years of our friendship was, I think, quite beautiful. The staff wanted the more austere face of her last years."

The last wood engraving I received from him, his New Year's card for 1987, was a print of the block on which he tested his graver. Fritz died November 30, 1990, having suffered the same disease which took his father's life. "His body gave in," his wife Antonie wrote me in a letter. "Parkinson's disease is a vicious one, but Fritz's spirit did not give in!"

His graver is still, but Fritz's work touched countless lives and continues to do so.

"I would like to think," Fritz once wrote, "that through my work as an artist and through my personal relations, I have been able to make friends all over the world. I am grateful for the fact that I was given the talents of an image-maker, enabling me to interpret the great classics as well as expressing my own thoughts, and [as a teacher] that I was allowed to pass on my experiences to generations of young artists. It has been my hope that in a small way I have been able to contribute to peace through compassion and also to the recognition, as George Fox said three centuries ago, 'that there is that of God in everyone,' a conception of the sanctity of human life which precludes all wars and violence."

TIME FOR TESTING

FOR LOOKING BACK

ON YEARS OF STRUGGLE

TO CREATE A SOURCE OF LIGHT

OUT OF A PIT OF DARKNESS

HAVE I KEPT MY GRAVER SHARP

AT THE RIGHT ANGLE

A TINY VOICE

IN A SEA OF TROUBLE

LONGING TO BE HEARD

EAGER FOR FRIENDSHIP

FREELY GIVEN

TO WEARY PILGRIMS

SUCH AS YOU AND ME.

FRITZ EICHENBERG

(text accompanying print of his proof block, New Year's greetings sent out in 1986)

SCENES FROM THE OLD TESTAMENT

(1955)

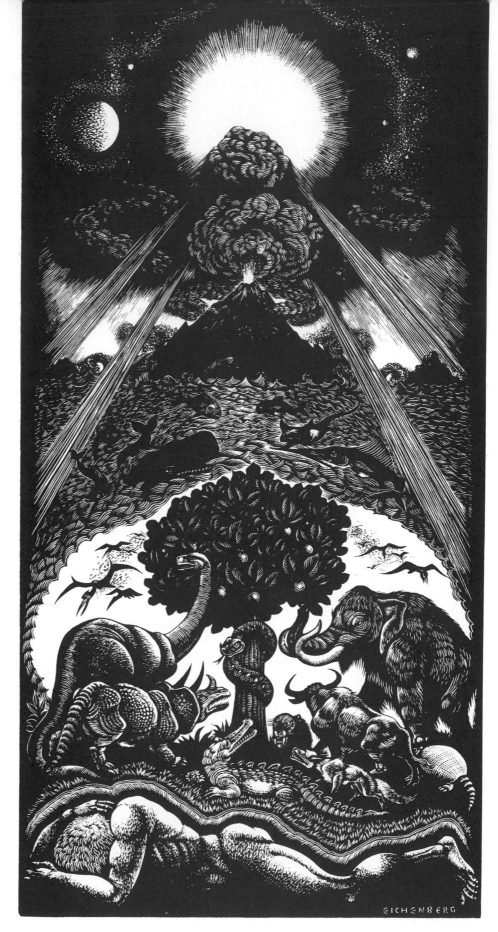

THE
FIRST
SEVEN DAYS

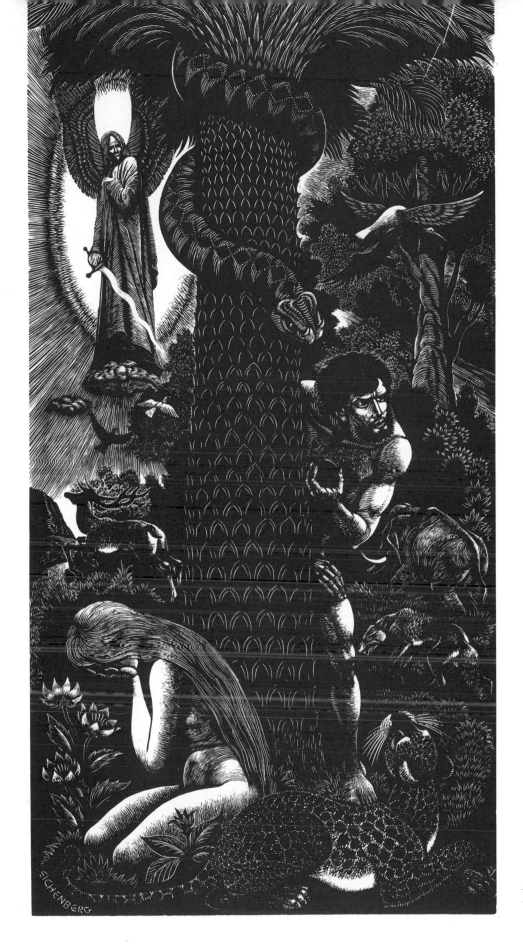

AND THEIR EYES
WERE OPENED

27

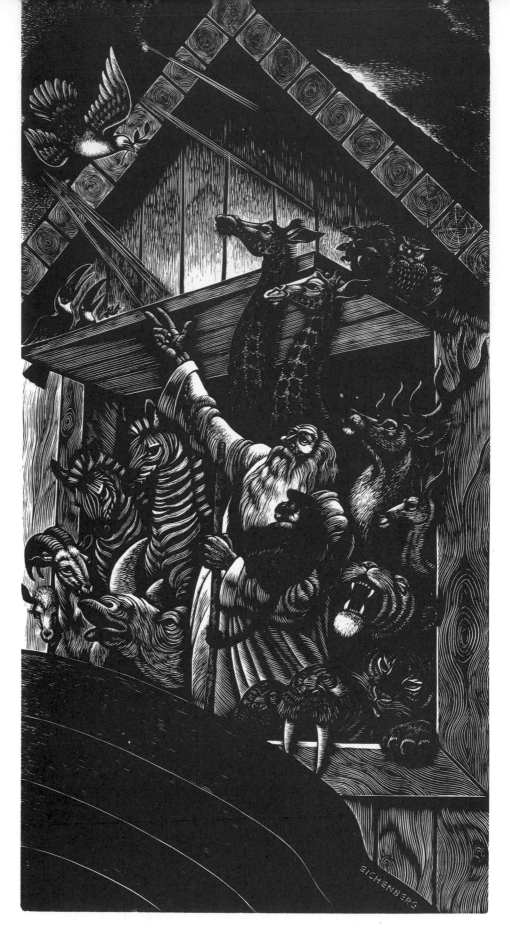

AND
IN HER MOUTH
WAS AN
OLIVE LEAF

28

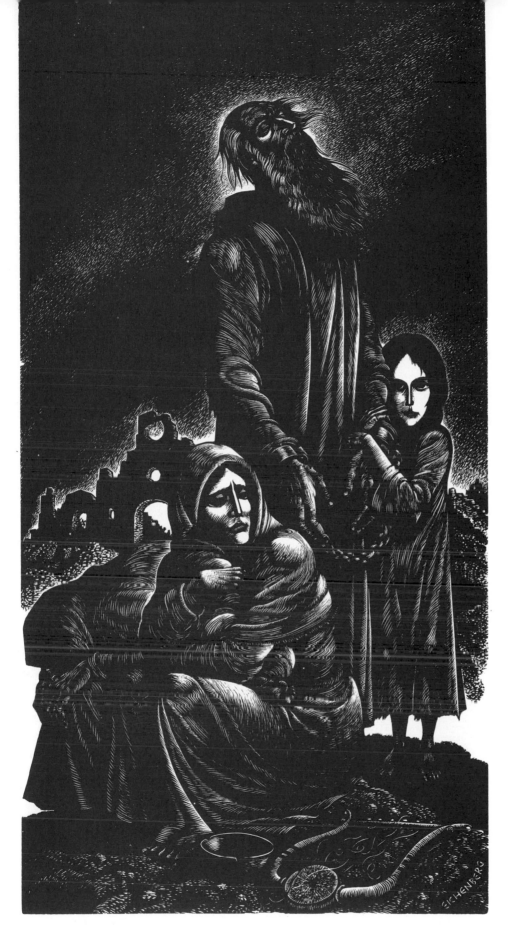

THE
LAMENTATIONS
OF JEREMIAH

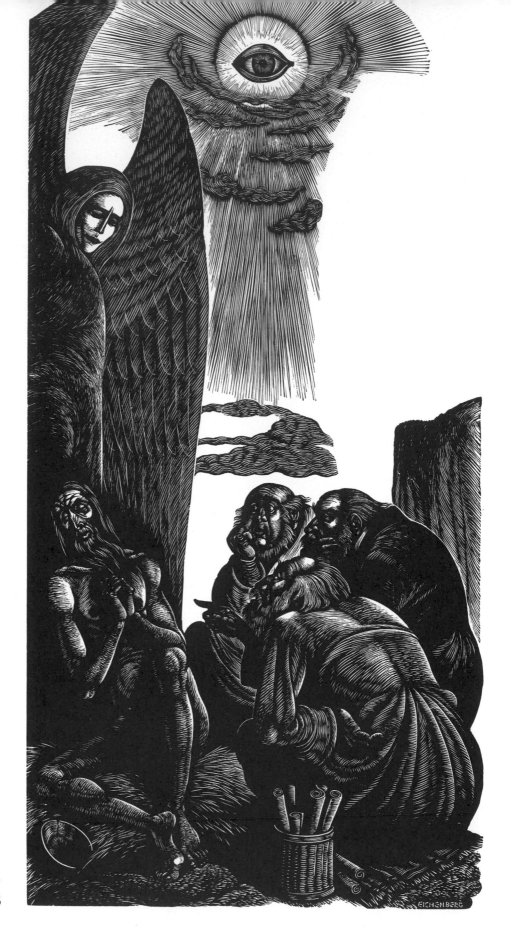

THE
BOOK OF JOB

30

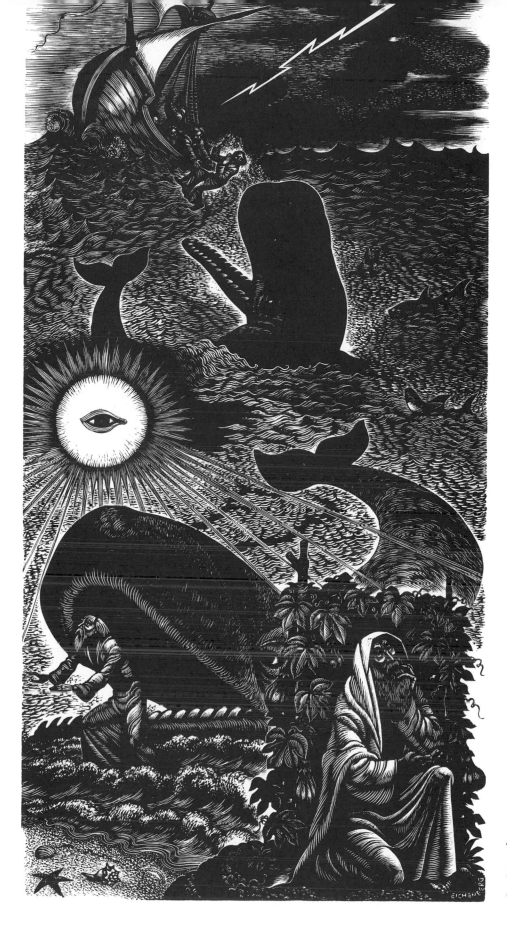

THE
STORY
OF JONAH

SCENES FROM THE LIFE OF CHRIST

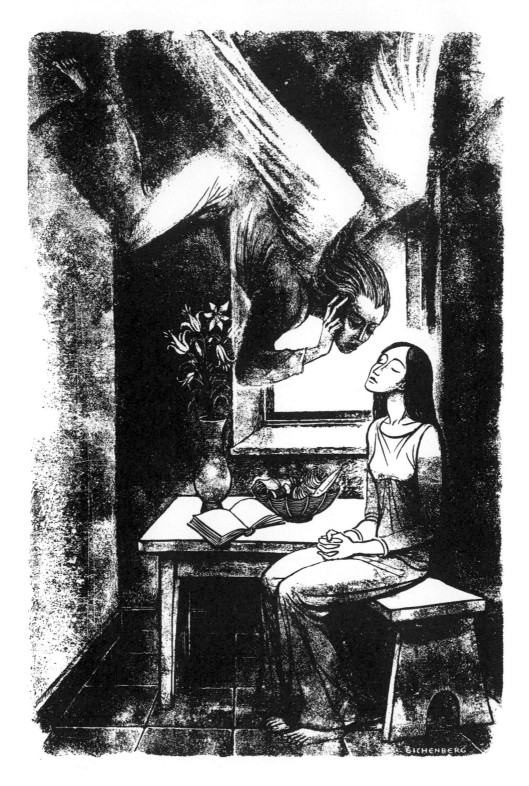

ANNUNCIATION (1955)

Room for Christ

by Dorothy Day

It is no use saying that we are born two thousand years too late to give room to Christ. Nor will those who live at the end of the world have been born too late. Christ is always with us, always asking for room in our hearts.

But now it is with the voice of our contemporaries that He speaks, with the eyes of store clerks, factory workers, and children that he gazes; with the hands of office workers, slum dwellers, and suburban housewives that He gives. It is with the feet of soldiers and tramps that He walks, and with the heart of anyone in need that He longs for shelter. And giving shelter or food to anyone who asks for it, or needs it, is giving it to Christ.

We can do now what those who knew Him in the days of His flesh did. I am sure that the shepherds did not adore and then go away to leave Mary and her Child in the stable, but somehow found them room, even though what they had to offer might have been primitive enough. All that the friends of Christ did for Him in His lifetime, we can do. Peter's mother-in-law hastened to cook a meal for Him, and if anything in the Gospels can be inferred, it surely is that she gave the very best she had, with no thought of extravagance. Matthew made a feast for Him, inviting the whole town, so that the house was in an uproar of enjoyment, and the straitlaced Pharisees—the good people—were scandalized.

The people of Samaria, despised and isolated, were overjoyed to give Him hospitality, and for days He walked and ate and slept among them. And the loveliest of all relationships in Christ's life, after His relationship with his Mother, is His friendship with Martha, Mary, and Lazarus and the continual hospitality He found with them . . .

If we hadn't got Christ's own words for it, it would seem raving lunacy to believe that if I offer a bed and food and hospitality to some man or woman or child, I am replaying the part of Lazarus or Martha or Mary, and that my guest is Christ. There is nothing to show it, perhaps. There are no halos already glowing round their heads—at least none that human eyes can see. It is not likely that I shall be vouchsafed the vision of Elizabeth of Hungary, who put the leper in her bed and later, going to tend him, saw no longer the leper's stricken face but the face of Christ . . .

Some time ago I saw the death notice of a sergeant-pilot

My soul magnifies the Lord,
and my spirit rejoices in God my
* Savior,*
because he has regarded the
* lowliness*
of his handmaiden.
For behold, henceforth all
generations will call me blessed;
for he who is mighty has done great
* things for me,*
and holy is his name.
And his mercy is on those who fear
* him*
from generation to generation.
He has shown strength with his
* arm,*
he has scattered the proud in the
* conceit of their hearts,*
he has put down the mighty from
* their thrones,*
and exalted the lowly;
the hungry he has filled with good
* things,*
and the rich he has sent empty
* away.*
He has helped his servant Israel,
mindful of his mercy,
as he promised our fathers,
to Abraham and to his children
* forever.*

LUKE 1:46-55

who had been killed on active service. After the usual information, a message was added which, I imagine, is likely to be imitated. It said that anyone who had ever known the dead boy would always be sure of a welcome at his parent's home. So, even now that the war is over, the father and mother will go on taking in strangers for the simple reason that they will be reminded of their dead son by the friends he made.

That is rather like the custom that existed among the first generations of Christians, when faith was a bright fire that warmed more than those who kept it burning. In every house then, a room was kept ready for any stranger who might ask for shelter; it was even called "the stranger's room"; and this not because these people, like the parents of the dead airman, thought they could trace something of someone they loved in the stranger who used it, not because the man or woman to whom they gave shelter reminded them of Christ, but because — plain and simple and stupendous fact — he was Christ.

It would be foolish to pretend that it is always easy to remember this. If everyone were holy and handsome, with "alter Christus" shining in neon lighting from them, it would be easy to see Christ in everyone. If Mary had appeared in Bethlehem clothed, as St. John says, with the sun, a crown of twelve stars on her head, and the moon under her feet, then people would have fought to make room for her. But that was not God's way for her, nor is it Christ's way for Himself, now when He is disguised under every type of humanity that treads the earth . . .

In Christ's life, there were always a few who made up for the neglect of the crowd. The shepherds did it; their hurrying to the crib atoned for the people who would flee from Christ. The wise men did it; their journey across the world made up for those who refused to stir one hand's breadth from the routine of their lives to go to Christ. Even the gifts the wise men brought have in themselves an obscure recompense and atonement for what would follow later in this Child's life. For they brought gold, the king's emblem, to make up for the crown of thorns that He would wear; they offered incense, the symbol of praise, to make up for the mockery and the spitting; they gave Him myrrh, to heal and soothe, and He

was wounded from head to foot and no one bathed His wounds. The women at the foot of the Cross did it too, making up for the crowd who stood by and sneered.

We can do it too, exactly as they did. We are not born too late. We do it by seeing Christ and serving Christ in friends and strangers, in everyone we come in contact with.

All this can be proved, if proof is needed, by the doctrines of the Church. We can talk about Christ's Mystical Body, about the vine and the branches, about the Communion of Saints. But Christ Himself has proved it for us, and no one has to go further than that. For He said that a glass of water given to a beggar was given to Him. He made heaven hinge on the way we act toward Him in His disguise of commonplace, frail, ordinary humanity.

Did you give Me food when I was hungry?

Did you give Me to drink when I was thirsty?

Did you give Me clothes when My own were all rags?

Did you come to see Me when I was sick, or in prison or in trouble?

And to those who say, aghast, that they never had a chance to do such a thing, that they lived two thousand years too late, He will say again what they had the chance of knowing all their lives, that if these things were done for the very least of His brethren they were done to Him.

For a total Christian, the goad of duty is not needed — always prodding one to perform this or that good deed. It is not a duty to help Christ, it is a privilege. Is it likely that Martha and Mary sat back and considered that they had done all that was expected of them — is it likely that Peter's mother-in-law grudgingly served the chicken she had meant to keep till Sunday because she thought it was her "duty"? She did it gladly; she would have served ten chickens if she had had them.

If that is the way they gave hospitality to Christ, it is certain that that is the way it should still be given. Not for the sake of humanity. Not because it might be Christ who stays with us, comes to see us, takes up our time. Not because these people remind us of Christ, as those soldiers and airmen remind the parents of their son, but because they are Christ, asking us to find room for Him, exactly as He did at the first Christmas.

December 1945

We are told to put on Christ and we think of Him in His private life, His life of work, His public life, His teaching and His suffering life. But we do not think enough of His life as a little child, as a baby. His helplessness. His powerlessness. We have to be content to be in that state too. Not to be able to do anything, to accomplish anything.

DOROTHY DAY (1953)

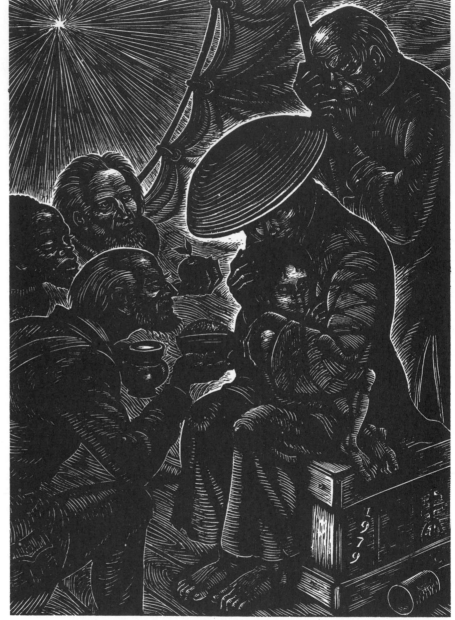

In this world, this demented inn, in which there is absolutely no room for Him at all, Christ has come uninvited. But because He cannot be at home in it, because He is out of place in it, His place is with those others for whom there is no room. His place is with those who do not belong, who are rejected by power because they are regarded as weak, those who are discredited, who are denied the status of persons, who are tortured, bombed, and exterminated. With those for whom there is no room, Christ is present in the world. He is mysteriously present in those for whom there seems to be nothing but the world at its worst . . . It is in these that He hides Himself, for whom there is no room.

THOMAS MERTON

EPIPHANY (1979)

36

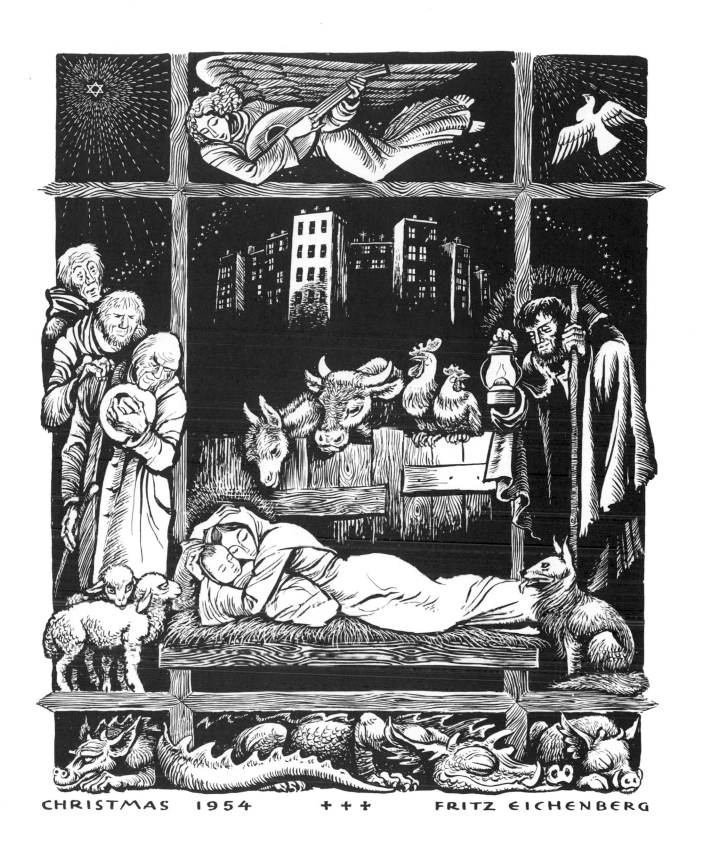

CHRISTMAS (*1954*)

Man is a creature of body and soul, and he must work to live, he must work to be co-creator with God, taking raw materials and producing for human needs. He becomes God-like, he is divinized not only by the Sacrament but by his work, in which he imitates his Creator, in which he is truly "putting on Christ and putting off the old man." He must be taught those words of Jesus to St. Catherine of Siena, "I have left Myself in the midst of you, so that what you cannot do for Me, you can do for those around you."

DOROTHY DAY (1962)

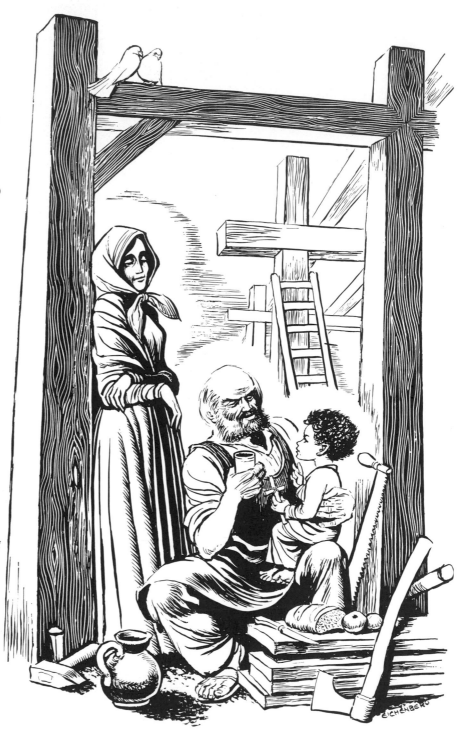

Christ, the Son of Man, lived among us for thirty-three years. For many of those years He lived in obscurity. When he was a baby His foster father had to flee with Him into Egypt. Joseph was a carpenter, a common laborer, and probably had no more savings than the majority of workers. When he tramped the long weary road, in the heat and dust of the deserts, he, too, and Mary and the Child were doubtless hungry. Do any of those hitchhikers, fleeing from the dust bowl into southern California across mountain and desert, remember, as they suffer, the flight into Egypt?

DOROTHY DAY (1937)

JOSEPH THE CARPENTER (*1955*)

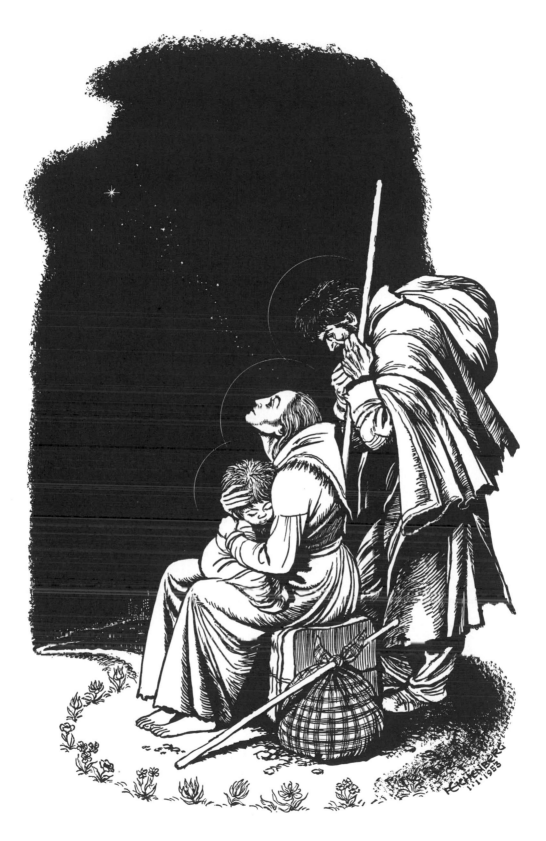

FLIGHT TO EGYPT (*1953*)

MARCH, 1957
ST. JOSEPH'S HOUSE
223 CHRYSTIE ST.
NEW YORK 2, N. Y.

Dear Fellow Workers in Christ:

Last week we were reading Helen Waddell's translation of The Desert Fathers and she writes, "their every action showed a standard of values which turned the world upside down. It was their humility, their gentleness, their heartbreaking courtesy that was the seal of their sanctity."

I could not help but think of this when we were saying our daily rosary in the library and was distracted by the bent backs, the crouching figures, the absorption of those who live with us, work with us and in these few moments each day pray with us. (It is the only religious exercise we have, and that, of course, is not compulsory.) I'm not meaning to compare the men of our household with the Desert Fathers, but just the same, their lives do indeed contrast with that of the world—their baggy clothes which never fit, their complete lack of self-consciousness, their satisfaction with little—food, warmth, shelter, and a chance to live with and serve others. These are the men who make the coffee and put out the bread in the mornings, who mop up the floors, who prepare and cook the meals and wash up after them, who paint the house, put new pipe in it, who see improvements to be made and make them, who help get the paper out and this appeal too, who take up each need as it comes, whether of food, or clothes, and give of their own, too. One feast day we had chicken and the very men who prepared it had to take eggs because it would not stretch.

And the beauty of it is that in every parish, in every poor neighborhood one could find in a day the men to run a house of hospitality, if only a few— two or three—would get one started.

God knows, there is always the need; the poor we'll always have with us, poor in mind and soul and body. We all fall into that category in one way or another. We are the stewards, the staff here at The Catholic Worker, and we are not ashamed to beg from you who have, for those who have not, because we know you are ready to give.

We are beginning our 25th year this May and the soup line goes on, and though we get the clothes we need, and the furnishings, we have to pay for our food, our fuel, our utilities. Sixty cents will pay for a bed in a cubicle in a hotel on the Bowery for our overflow.

If everyone would help a little, if you in your abundance will supply their want, as St. Paul said, we will be most deeply grateful. We ask in the name of St. Joseph, whose month this is, and he will bless you, as he has always blessed us, and will teach you to grow in that love of God because you have showed merciful love for his creatures.

Gratefully, in the love of God,
Dorothy Day.

JESUS AND THE LEPER (*1957*)

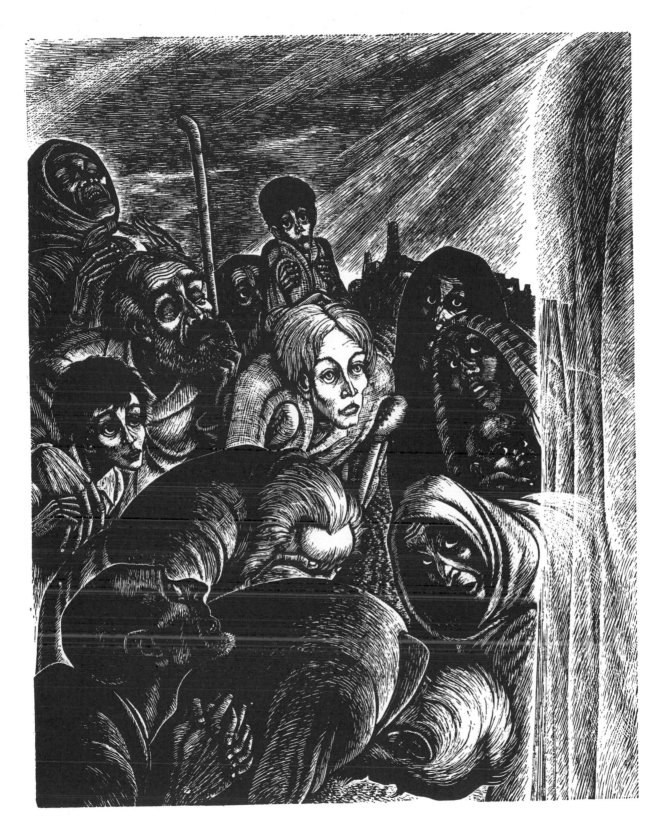

THE LIGHT (*1951*)

Compassion—it is a word meaning to suffer with. If we all carry a little of the burden, it will be lightened. If we share in the suffering of the world, then some will not have to endure so heavy an affliction. It evens out. What you do here in New York, in Harrisburg, helps those in China, India, South Africa, Europe, Russia, as well as in the oasis where you are. You may think you are alone. But we are members one of another. We are children of God together.

DOROTHY DAY (1948)

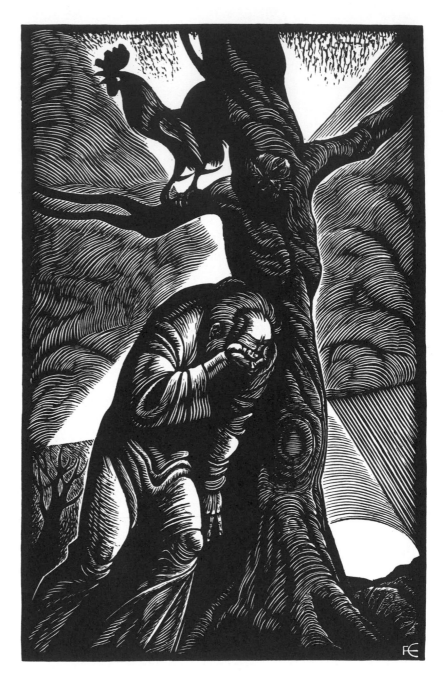

Christ healing the sick, raising the dead, etc.—that is the humble, human, almost low part of His mission. The supernatural part is the sweat of blood, the unsatisfied longing for human consolation, the supplication that He might be spared, the sense of being abandoned by God.

SIMONE WEIL

THE NINTH HOUR (*1957*)

42

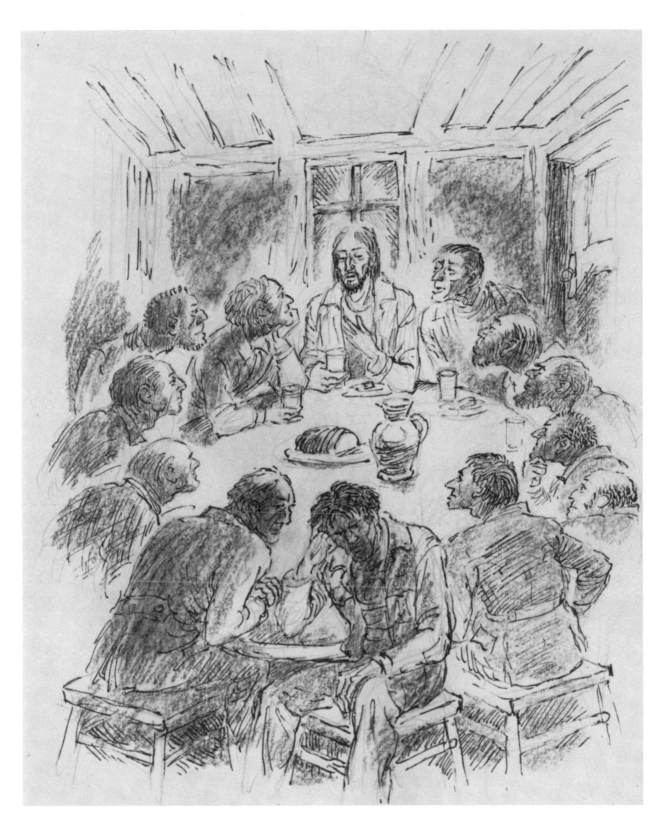

THE LAST SUPPER (*1985*)

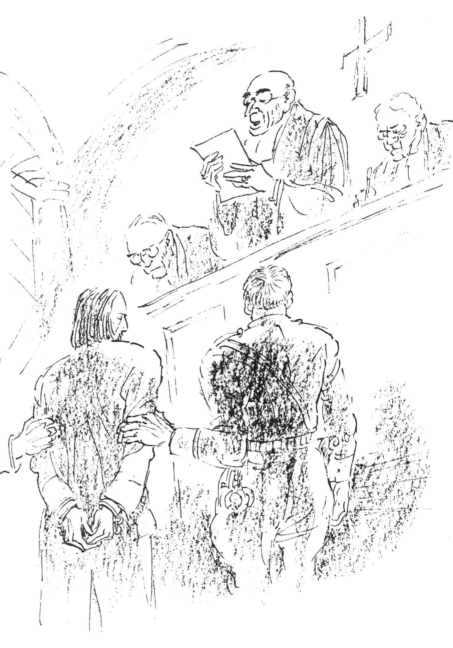

What glorious hope! There are all those who will discover that their neighbor is Jesus himself, although they belong to the mass of those who do not know Christ or who have forgotten Him. And nevertheless they will find themselves well loved. It is impossible for any one of those who has real charity in his heart not to serve Christ. Even some of those who think they hate Him have consecrated their lives to Him; for Jesus is disguised and masked in the midst of men, hidden among the poor, among the sick, among prisoners, among strangers. Many who serve Him officially have never known who He was, and many who do not even know His name will hear on the last day the words that open to them the gates of joy: "Those children were I, and I those working men. I wept on the hospital bed. I was that murderer in his cell whom you consoled."

FRANCOIS MAURIAC

Martyrdom is not gallantly standing before a firing squad. Usually it is the losing of a job because of not taking a loyalty oath, or buying a war bond, or paying a tax. Martyrdom is small, hidden, misunderstood. Or if it is a bloody martyrdom, it is the cry in the dark, the terror, the shame, the loneliness, nobody to hear, nobody to suffer with, let alone to save. Oh, the loneliness of all of us in these days, in all the great moments of our lives, this dying which we do, by little and by little, over a short space of time or over the years. One day is as a thousand in these crises. A week in jail is as a year.

DOROTHY DAY (1951)

SENTENCING (*1985*)

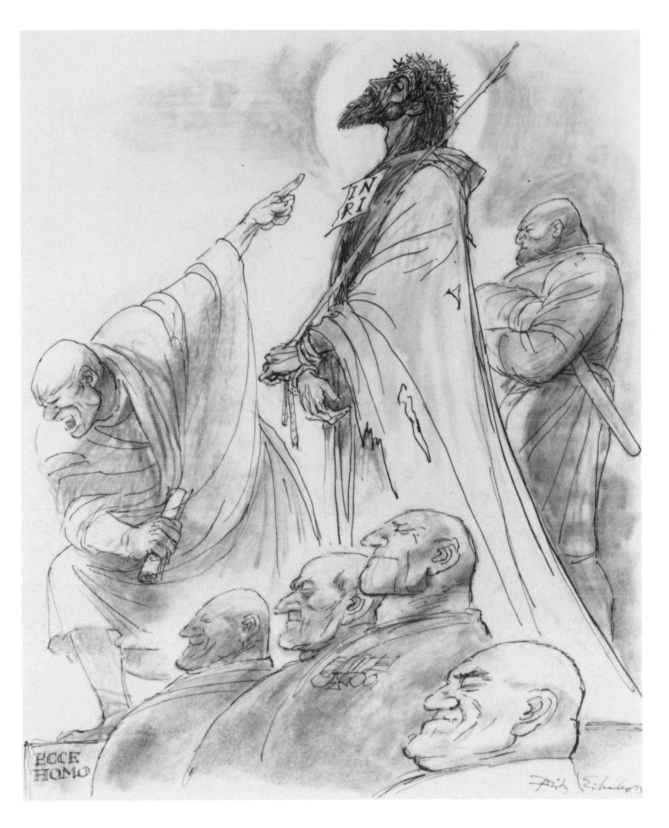

ECCE HOMO (*1985*)

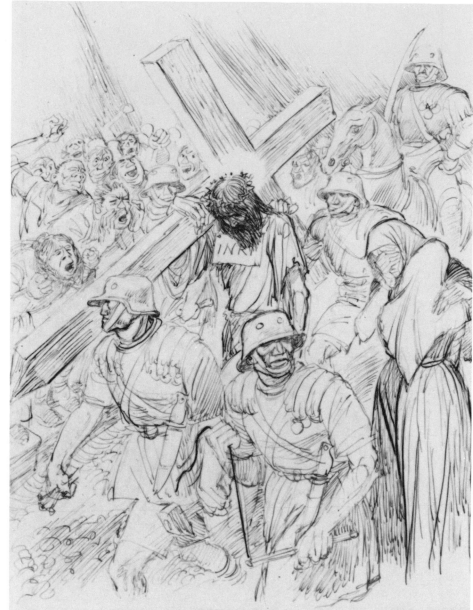

*One more sin, suffering Christ,
worker Yourself, for You to bear. In
the garden of Gethsemane, You
bore the sins of all the world—You
took them on Yourself, the sins of
those police, the sins of the Girdlers
and the Schwabs, of the Graces of
this world. In committing them,
whether ignorantly or of their own
free will, they piled them on Your
shoulders, bowed to the ground
with the weight of the guilt of the
world, which You assumed because
You loved each of us so much. You
took them on Yourself, and You
died to save us all. Your Precious
Blood was shed even for that
policeman whose cudgel smashed
again and again the skull of that
poor striker, whose brains lay
splattered on the undertaker's slab.
And the sufferings of those strikers'
wives and children are completing
Your suffering today.
Have pity on us all, Jesus of
Gethsemane . . . who have not
worked enough for "a new heaven
and a new earth wherein justice
dwelleth."*

DOROTHY DAY (1937)

ON TO GOLGOTHA (*1985*)

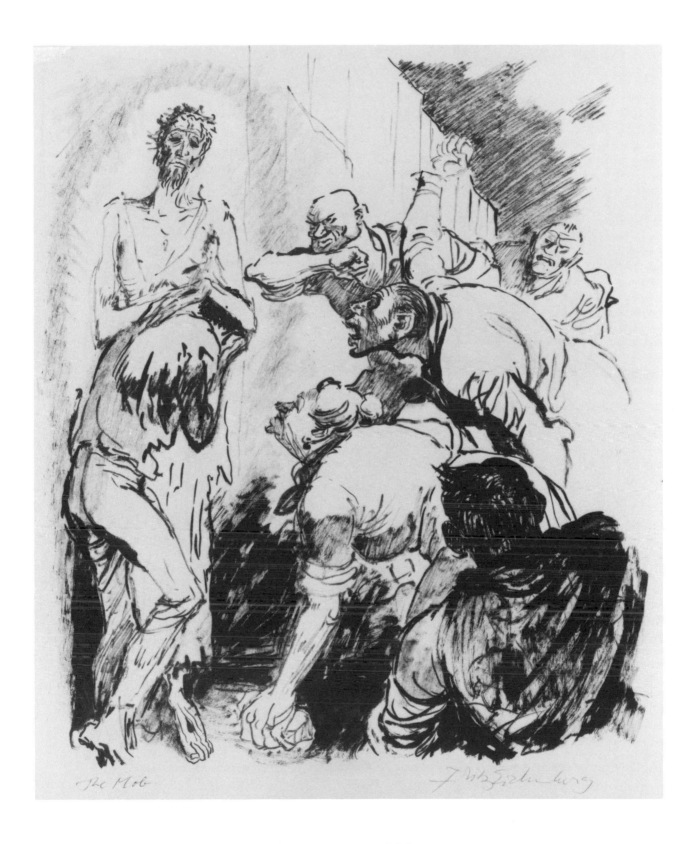

THE MOB (*1985*)

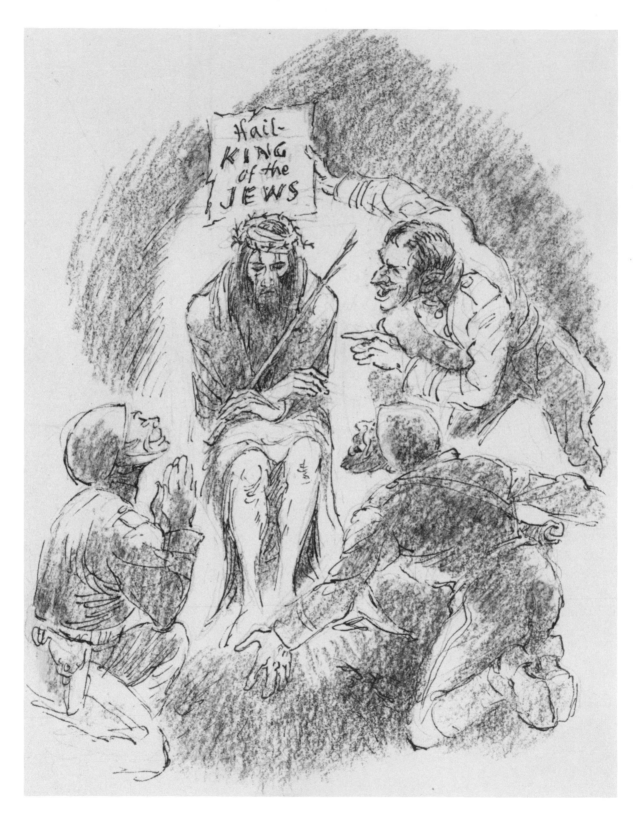

KING OF THE JEWS (*1985*)

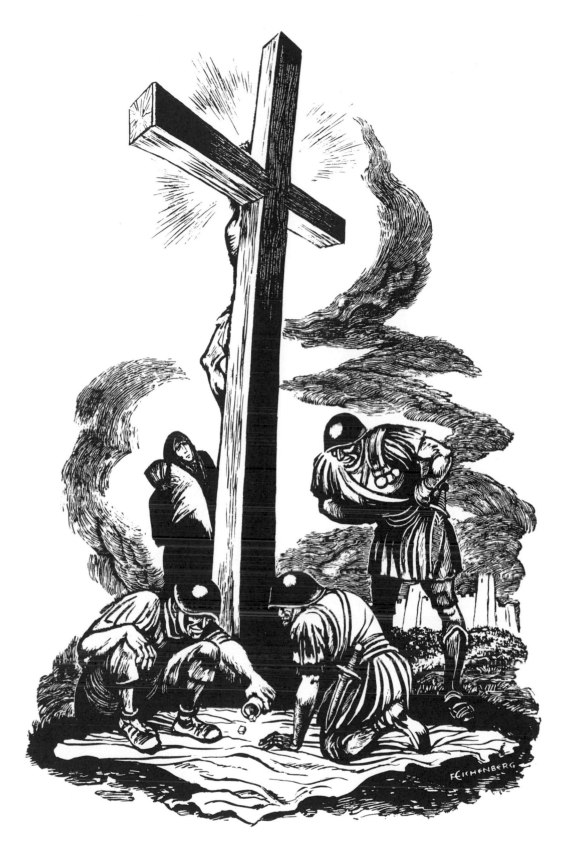

CASTING THE DICE (*1954*)

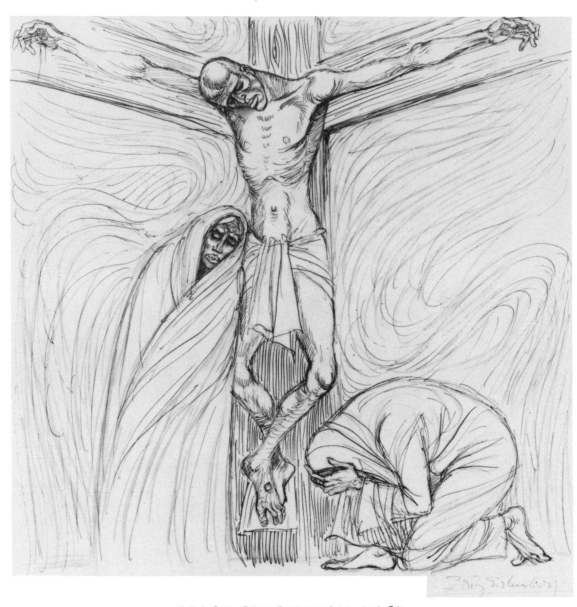

BLACK CRUCIFIXION (1963)

To our bitterest opponents we say:
We shall match your capacity to
inflict suffering by our capacity to
endure suffering. We shall meet
your physical force with soul force.
Do to us what you will, we shall
continue to love you. We cannot
in all good conscience obey
your unjust laws, because
noncooperation with evil is as
much a moral obligation as is
cooperation with good. Throw us in
jail, we shall still love you. Bomb
our homes and threaten our
children, we shall still love you.

Send your hooded perpetrators of
violence into our community at the
midnight hour and beat us and
leave us half dead, and we shall
still love you. But be assured that
we will wear you down by our
capacity to suffer. One day we shall
win freedom, but not only for
ourselves. We shall so appeal to
your heart and conscience that we
shall win you in the process and
our victory will be a double victory.

MARTIN LUTHER KING, JR.

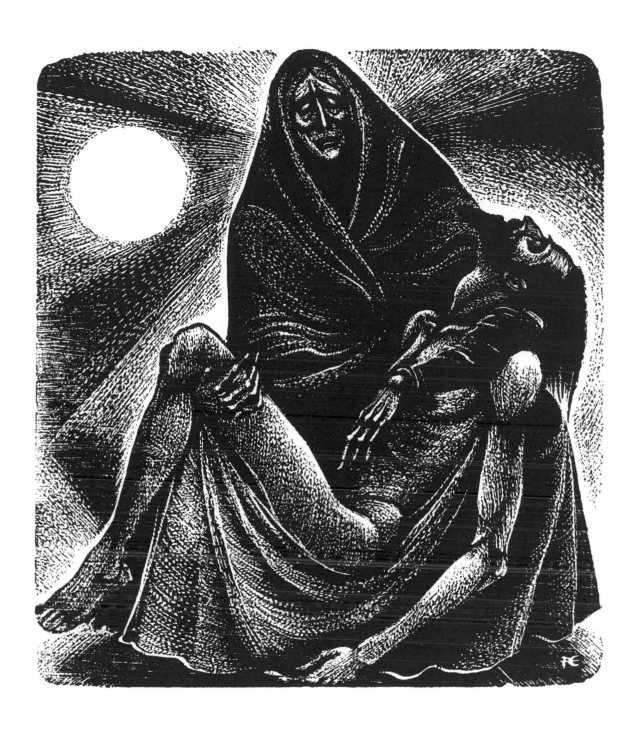

PIETÀ (*1955*)

DOUBTING THOMAS (*1985*)

This interview occurred in the summer of 1981. It was published in the October-November 1981 edition of The Catholic Worker, *in celebration of Fritz's eightieth birthday.*
—Robert Ellsberg

Revealing the Inner Light

An Interview with Fritz Eichenberg

How did your relationship with the Catholic Worker begin?

I met Dorothy sometime around 1949 at a conference on religious publishing at the Quaker retreat center, Pendle Hill. My friend Gilbert Kilpack had been raving about her for years and had shown me *The Catholic Worker*. He told me that Dorothy would be at this conference and that I must come and get acquainted with her. So I came. Gilbert arranged for us to sit together and so we talked. When I told her I was an artist she remembered seeing my work—*Crime and Punishment*, I think. Of course, she loved Dostoyevsky. She wished she could have such art in *The Catholic Worker*, she said. Dorothy wanted something emotional, something that would touch people through images, as she was trying to do through words, and something that would communicate the spirit of the Catholic Worker to people who, perhaps, could not read the articles.

"Would you do some work for us?" she asked. I said at once that I would. I was so happy that she had asked me. Well, a few days later she wrote and asked me to do some pictures of her favorite saints. She had a list, and since I hadn't heard of most of them she sent me a little book of *The Lives of the Saints*. From then on I found it easy to slip into this. Although I am still a Friend and a Quaker, I always thought that the Catholic Worker would be or should be an example for Friends in general, to convey the spirit of poverty and unconditional devotion to nonviolence that most Friends profess but not many live up to. Dorothy stood for everything I thought would make this world a better place. She cared for the underdog, the oppressed, the poor, the ones who were easily discarded by society as hopeless cases. They needed help and she helped them.

I never knew thirty years ago that my humble work for *The Catholic Worker* would become almost an identification for me. Wherever I speak people always come up and say "I've seen your work in the *CW*." I was just so taken with

The new social order as it could be and would be if all men loved God and loved their brothers because they are all sons of God! A land of peace and tranquility and joy in work and activity. It is heaven indeed that we are contemplating. Do you expect that we are going to be able to accomplish it here? We can accomplish much, of that I am certain. We can do much to change the face of the earth, in that I have hope and faith. But these pains and sufferings are the price we have to pay. Can we change men in a night or a day? Can we give them as much as three months or even a year? A child is forming in the mother's womb for nine long months, and it seems so long. But to make a man in the time of our present disorder with all the world convulsed with hatred and strife and selfishness, that is a lifetime's work and then too it is not accomplished. We are never going to be finished!

DOROTHY DAY

Dorothy—and she apparently with me and my work. She was so hungry for art. She was and still is such a great factor in my life and she helped me in so many ways through difficult phases of my struggle to become a better person. And I am still struggling.

She must have recognized in you a kindred spirit. You like to draw so much on the same literature and tradition.

I'm an emotional person and that has been my hallmark all throughout my life. I get very easily carried away, and sometimes I go too far in my emotion—something I discovered only recently, very late in my life. And certain work I have done has touched people so deeply that they can't get the images out of their system—as for instance, Heathcliff under the tree from *Wuthering Heights*. Wherever I go, where there is an exhibition of my work, I can be sure to meet my Heathcliff. It is not a work I greatly cherish. It wears thin if I see it too often. Then I think of St. Francis: "Lord, make me an instrument of Thy peace." I feel like an instrument some power plays on. I sometimes create these images like a somnambulist and I can't explain them. I believe that no matter what you do, in whatever human endeavor, if you are not in a state of grace, you fail. If I do certain things on commission I often fail. The motivation for my work has to come out of my own world, my own experience.

And yet much of your work is done on commission.

Yes, but it must be a work which inspires me. A publisher suggests a book to me and I read it over and over to feel its pulse, and I can't accept it unless I feel a spiritual kinship with the author. As an example, recently a publisher suggested that I illustrate Dickens' *Great Expectations*. For me, there was something lacking in it. Maybe the tremendous facility with which he wrote turns me off—almost too great a facility. Dostoyevsky inspires me. Tolstoy inspires me, Dorothy inspired me. It's that simple.

Would Dorothy suggest topics for you?

Yes. Sometimes, but she never told me how to do it. Often the ideas just came to me and I knew they belonged to the *Worker*. Take the "Labor Cross" for example—you know, the cross with various workers in the shelter of it. I just did it because of my devotion to Dorothy and her cause. And yet it has been reprinted all over the world.

When I met Dorothy I said, "You know I am not a Catholic. Have you asked Catholic artists?" She said, "I can't pay them." Well, the fact that I don't get paid for it makes it more valuable to me. There is no money changing hands. I can always make a living and I don't need much, so it's a privilege for me to be able to do what I really feel strongly about, and participate in it.

What about the "Christ of the Breadlines"—Where did the idea for that come from?

That really came about because I was so impressed by the day-to-day operation of the house of hospitality, first on Mott Street, then on Chrystie Street. I was living in New York and I was there quite often. I remember that courtyard on Mott Street so vividly; it looked like a Brecht stage setting. There was a table in the middle with a little kerosene lamp. There were people leaning out of windows shouting to each other. And that breadline curled around the block with those ragged men and women, so injured and yet with a kind of silent dignity. I was very moved by that sight, and I imagined Christ among them.

Even before you met Dorothy you were producing woodcuts of St. Francis. What attracted you to him?

Even before I became a Friend I saw St. Francis as the universal saint. There are very few who stir me as he does. He was a poet, he came close to you, the saint of the poor, a very moving human being who became a saint almost incidentally, if you understand me. I feel he may have had the same feeling as Dorothy, rejecting the burden of sainthood while he lived. To be crowned by whatever hierarchy is in office at the moment has somehow never appealed to me, and I don't think it appealed to St. Francis, nor Dorothy, ever.

When did you decide to become an artist?

Since I was a young child there was nothing else I wanted to do. I felt unhappy as a child. I was displaced in a rather brutal school which did not take any consideration of the emotional needs of a sensitive child. I suffered through eleven years and then I became an apprentice in a lithographic shop in Cologne, and it was then that I started to live. It was just after the First World War. We had been through so many crises, revolutions, wars and disillusionments. We were all half-starved, but I was very happy—we

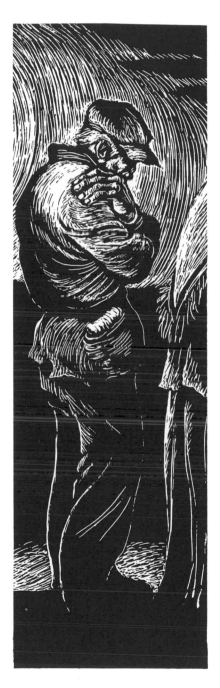

were young and we were in love with art and life.

Had you been raised as a religious Jew?

I would say I had no religion of any kind. I grew up with the same mistaken notion as other assimilated Jews of that time, thinking we were German. We were not a religiously motivated family. We led a normal bourgeois German life. When I was a little kid and the Emperor came to Cologne, we pupils were lined up along the route he took and waved our little flags. The poetry and the songs we learned in school were all for the glorification of the German Empire. We swore allegiance to the Emperor when we were little children and we were raised consciously to think of the Emperor as a divine person. The sanctity of the monarchy was officially accepted. Of course, it was all the great deception, but who could enlighten you when you were so little? You just followed the flag, and my parents fell into the same kind of pattern. My father's name was Siegfried, don't laugh, and mine was Fritz—a name I always hated. My older sister was called Friederike Charlotte, the name of a Prussian princess. It was a fool's paradise, and it ended in disaster.

What made you decide to leave?

For some reason my angel protected me and made me feel the advent of evil without knowing why—I wanted to get out of Germany even before Hitler came to power. I hated the regimentation, I hated the military who were evident wherever you went. Every mailman, every station master, wore a uniform, and inspired respect. And whoever was a civilian was hardly considered a full-fledged German citizen. Then came the revolution. When I was an apprentice in Cologne, after the war, I thought a new world was beginning, better than the one we left behind. Democracy was triumphant, "Let Freedom ring," I thought. And it took just ten years for it all to fall apart.

As the Nazis were rising I was a journalist/artist in Berlin, working for middle-of-the-road publications. I did as much as I could to let off steam in anti-Hitler cartoons, but it was ineffective. I knew no earthly power could stop what was happening then, so I began to prepare to leave. I got some commissions from newspapers, got a passport as a journalist. I wanted to go to Mexico—Rivera, Orozco, they were my

idols. Mexico, I thought, was the place for an artist with a social conscience.

Did the fact of your being a Jew make it seem more urgent to get out?

Strangely, I didn't think of myself as a Jew. I, myself, experienced no anti-Semitism. My sisters were blond and blue-eyed, you know, "Aryan types." Of course, our time would have come, but I had only a vague foreboding. I left Germany in 1933, practically on the day when Hitler became Chancellor. I went to Guatemala and Mexico and entered this country through Texas. Then I went to New York and, all of a sudden, I met so many people who wanted to have a look at me — you know, the first refugee, so to speak, and I made many friends.

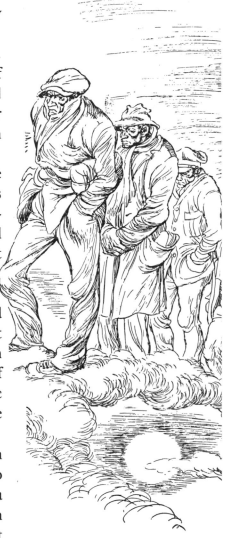

But I had to go back to Germany to get my wife and baby. At this point, my new friends told me I was mad, and of course it was a very risky thing, but I had no choice. It turned out the police weren't looking for me yet — they had bigger fish to fry — and so I managed to get in and out by the skin of my teeth.

We settled in Riverdale and I got a job as an artist with the WPA (Works Progress Administration) making twenty dollars a week, and taught at the New School. We artists had complete freedom to do whatever we wanted, and I made several wood engravings of St. Francis among other things. It must have been in my system. That was in 1934, or so.

When did you become a Quaker?

In 1939, at a critical time for me. The war had started and I still had friends in Germany, though I had managed to get my family out. It was a painful experience. I got to Quakerism through Zen Buddhism, the quietness of the Zen form of worship — to sit and empty your mind, to let the spirit of the Great Tao stream into you and fill you. I found this in a time of crisis.

My wife had died in 1937. Some kind of malfunction on an operating table. I still don't know exactly what occurred to this young woman, so full of life and wanting to live. I had a young daughter to take care of, but my nerves broke down and my will to live. I went into hiding for a year. I didn't want to see anyone. A teacher at the Ethical Culture School finally broke through the security my friends had established for

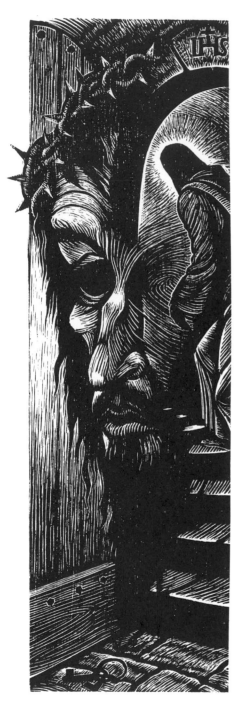

me. He was interested in Zen Buddhism and he began to read to me. These thoughts were so abstract that they helped me get my spirits back. In some of the books I read on Zen I found references to Rufus Jones and other Quakers connecting the East with the West, in thinking and spirituality. But slowly I realized that Zen was too foreign a form of worship for me, and I searched for the equivalent in a Western approach.

In 1939 I married again and suddenly found myself with a large family. I found the Quaker approach to life a unifying force to get all the members of my family together. My mother was never much interested in it, but my children fell into it. It worked for us. We became active members of Scarsdale Friends Meeting.

Were you attracted by the Christian aspect of Quakerism or was it the affinity with Eastern religion?

The figure of Christ, the rebellious visionary Jew, has been for me an overpowering influence on my whole thinking. I'm not good at analyzing that attraction, but it has to do with a reaction to suffering expressed in the symbol of the Cross.

There seem to be several images of Christ that occur in your work. First, there is the Passion, the man who suffers, the figure on the Cross. Then He appears as a kind of disturber of the status quo, a challenge to our easy consciences—the face who haunts your Grand Inquisitor. And then, of course, there is the figure of Christ who comes among us disguised in the body of the poor, the prisoner, the outcast.

The last is what Quakerism means to me. Friends believe that there is Christ in every man, in every living being. I believe firmly in this. To me it seems such a simple way of explaining to people what Friends stand for. If you see that of Christ in every living being you cannot kill. It's that simple. And all men become brothers.

So this meant becoming a pacifist as well?

Yes, whatever that implies. The word pacifist has, unfortunately, an institutional ring to it.

And here you were, a German refugee on the eve of World War II when everyone believed that force was the only solution . . .

Yes, it was a difficult conflict for me, but somehow it didn't

cause conflict with my friends. I have always had the blessings of my naivety. The artist has always been considered some sort of a fool anyway, and is able to say things that others can't say, because nobody takes him all that seriously.

How did the progress of your spiritual life relate to your development as an artist?

I've lived my life more or less on guidance from some unknown power — how I got where I am, it's very hard to say. I've followed more my own intuition than my reason. Speaking in practical terms, I really haven't achieved much. I just fail if I'm not inspired by some kind of urgency, by the need for a positive reaction. And my medium is visual. I can look at most of my work and teaching with the knowledge that I tried to bring people together — that through my work people may understand each other better. That is my main objective in life. And I hope it will make for peace.

Quite early in your career you chose the wood engraving as your particular medium.

The wood engraving and lithograph. These were the media in which I was trained, and I have found they are the most congenial for me. They have a symbolic value. They let you create light out of the dark as you face the black woodblock or the darkened surface of the lithographic stone. You spread light by the first touch of the graver or etching needle. You create a source of light which spreads over the "stage," picks out the main actors and sets the scene for their relationships.

Every time I begin work on a new woodblock, it is exciting to me. That, I think, is proof why it remains my medium. It has a mysterious, emotional impact because of the three-dimensional drama you can create out of it, that blank surface. You can make wispy skies, things which seem to dissolve on the woodblock, and you can make very solid forms, something that has such strength because the graver is able to move around an object and form it in its three-dimensionality. I can make the wind blow the overcoat of Heathcliff, and you almost see it move. It's a medium that is liable to endow an object with an inner life, with an action which you could not produce by the simple use of pen and ink.

I also get involved in the author of a book I'm working on, in the time in which he lived, in the characters of the story he's trying to tell. This medium allows me to make things

soft when needed, hard when needed. As far as faces are concerned, a touch of the graver expresses a different kind of mood. I can control this with a slight touch of the graver on the boxwood I use.

You are fascinated by faces, aren't you? You have done so many marvelous portraits: Mahatma Gandhi, Martin Buber, Peter Maurin.

To me this is the one way to get people to understand one another. If you don't look a person in the face, you won't know a thing about him. But everything is written there, you just have to learn how to read it.

You believe that what is inside people is revealed in their faces?

I think I do. And sometimes you see great love and compassion and sometimes you find great indifference. If a person's face is empty and there's nothing in it that catches me, I lose interest.

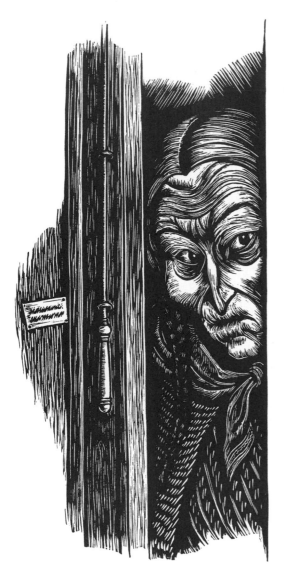

And you can communicate just through this contact face to face. Wherever I've gone, to the Soviet Union or Southeast Asia, I've had this experience. It had nothing to do with language, because I couldn't speak Russian or Hindi or Malaysian. It was simply a matter of contact face to face.

You have a special affection for the Russian novelists, don't you? The first book you illustrated was Crime and Punishment.

That is a book that has always meant a great deal to me. The starved student, Raskolnikov, believes he is above any moral law, commits a murder, treats himself like a little Napoleon, fighting an issue that is much too big for him. He pays a very heavy price for it, being sent into exile in Siberia. But in the end there is always redemption and this is what attracts me very greatly to the Russian novelists. They do not give an unrelieved account of human suffering. There is always proof in the end that through suffering one becomes purified, and that redemption is the hope for which you are praying, for which you are working.

I am interested in novels with psychological emphasis. The more difficult it is psychologically, the more I'm interested in it. And so, from *Crime and Punishment* I was led to Tolstoy, Turgenev, Pushkin.

I became known as the artist who does all "these morbid

things"—at least they were considered morbid at the time. But I think we've come a long way. People understand my work so much better now than they did forty years ago. They see what I meant to put into it, the redemption that comes through suffering. This is still my subject. I am currently illustrating Dostoyevsky's *House of the Dead*, the account of his experience as a political prisoner in Siberia. It is a book that might just as well have been written today. The experience of political prisoners is, sadly, a universal one.

Do you think that a social conscience affects the quality of an artist's work?

Who can say. Upton Sinclair was afflicted by a social conscience, and, you know, he was a mediocre writer. And yet he had a great influence on Dorothy, and on me while I was still in Germany.

What is art? I never give much credence to definitions because they're endless. You can walk through the Museum of Modern Art or the Guggenheim and go from exhibit to exhibit and ask, "Is this art, or isn't it?" My best definition is that it is purity of inspiration that comes to an artist— whether it's an Egyptian living four thousand years ago, or a cave artist who worked in murals, or Michelangelo. Sometimes they produced hack work because they were commissioned by some gallery, or pharaoh, to do something which they didn't find inspiring. But to determine what is art—could you do it? It is impossible. And I have tried. I have even written a book on the *Art of the Print*—my first attempt to be an art historian, so to speak. That took six years of my life. And I don't have the answers yet.

You know that quotation that comes from somewhere: "an outward sign of inward grace."

That's the definition of a sacrament.

Really?

Maybe art is a sacrament . . .

There's something to that. You know the tremendous inspiration that came from a block of marble in the hands of a Michelangelo. Before he's put his mallet and chisel to it, he already sees the form that emerges out of it. The material exerts a mysterious force, an inspiration, a spiritual quality. When I sit in front of the woodblock, it's an incredible sensation, and I've done many hundreds. The technical part

comes almost automatically, but the inspiration is a different thing. The technical part can be produced by a camera or a laser beam or whatever, but the spiritual force that's behind it, that's the mystery of it.

This instinct for the hidden life in the world around us— you seem to be describing the essence of contemplative experience.

You could put it that way.

What about religious art? Is there such a thing?

No, not in my opinion. Religious art is institutional and so, I would say, self-serving. Dorothy used to say, "May I never become an institution." The Catholic Church is an institution, committed to dogma and subservient art. Quakers, by tradition, are indifferent to art; that is not helpful either. They claim that the spirit of Christ is in each of us. The still inner voice, they call it, and it is hard to find an art form for it. But religion is just as hard to define as art, I believe.

Thomas Merton said that it was the spirit and not the subject matter that determined the religious nature of a work of art. He said a still life might have more religious content in it than a picture of the Crucifixion.

That's an interesting thought. I would be inclined to agree with him, just as I'm always inclined to agree with a nonconformer, a man of doubts. He thinks in new terms and tries to come down to the essence of the mystery which we shall never decipher.

Are you a man of doubts?

Yes, I am a man of doubts. But I'm also, on the other hand, an incorrigible optimist. I continue to have faith in something which I really can't define—the power that allows us to talk to one another and understand each other. This is so mysterious. Why does it work with us? Why doesn't it seem to work with so-called statesmen and politicians?

And the fact that we function even after grave disappointments and breakdowns, as I've experienced, and I'm sure you have, like every sensitive person. We are in a kind of twilight of evolution and we don't know where we are going to end up with another holocaust we can't seem to prevent. If we have gone too far in splitting atoms, we should turn back and return to the simple things where we work with our hands and till the soil and live with nature instead of

exploiting the Earth and defiling it continuously. And the older I get, the more I feel eventually to become one with this great mystery that we cannot solve while we are alive.

What are some of the projects that you have ahead of you?

There is one project over which I've been struggling through many sleepless nights. After the "Dance of Death" I feel I should do a "Dance of Life," as a kind of "counter-irritant." I don't know whether I can do it. I have struggled with it, but I can't put it down on paper until it is clear in my mind first.

That would be a change of pace! You seem to dwell more on the dark possibilities of human nature than the positive.

Yes, I have perhaps taken life too seriously. From my early childhood on—you know that little woodcut by Alfred Rethel, "Death as a Friend"—that was my first attempt to come to terms with it, and I was nine or ten years old at the time. And I remember my mother, whom I loved dearly, was very worried by the fact that I was thinking too deeply, and I got into a panic sometimes because I didn't know who am I, where am I, where am I going.

Like that legend on one of Gauguin's paintings . . .

Yes, and so many people have asked the same questions. She took me to a psychiatrist. I was a tiny kid, and he was a very famous professor in Cologne. He asked me some questions and finally he said, "I wish my son were like you. There's nothing wrong with you. You just think too deeply. Buy yourself a bicycle, get some fresh air." And what he told my mother, who was a very simple person, was something about *la maladie d'haut de la*—"beyond things." It must be some kind of psychologist's lingo—the sickness of thinking of the other world. I haven't forgotten that in seventy years. And I feel, in general, like lemmings which multiply too rapidly, that there is a suicidal streak in all of us. In our technological greed we have gone already too far. We have tried to come to terms with the cosmos via TV with Carl Sagan, and it has become almost a kind of parlor game. We forgot that the spirit is the more important thing, and we have neglected it in favor of a mad technology of finding out where the "other worlds" are and what the meaning of life is out there!

And so we know so much about the stars and moon and so little about ourselves.

That's my great objection to the space exploration before we have explored our own inner space. As an artist I would say, in general terms, that we are dependent on a certain sensitivity—whether we are writers or visual artists, or musicians—a sensitivity which is extraordinary in the true sense of the word. It is as painful as it is exhilarating. So we are always commuting between the two extremes of the agony and the ecstasy. The agony of finding out what life is all about—the ecstasy of being able to express our anxiety in a creative way that is understood by others.

What, then, is the role of the artist in society? Is the artist a therapist? An entertainer?

I hesitate to use myself as a measuring stick. An artist is an individual, and each one has a different motivation. If you are a painter of the traditional kind, a sanguine person, a man of action, a colorful personality who can slam the paint on the canvas like Jackson Pollack—no social responsibility there. And it isn't necessary.

The problem is that the moment you become aware that you are afflicted with a conscience, a social conscience, it changes your whole approach to any activity you're engaged in. I think we are always too hungry for a definition of the things we do and their meaning. I believe that one becomes fairly adjusted to life on this earth if you can trust your emotions or your instincts. It has worked in my case. I have survived tremendous emotional upheavals by following my "star." The majority of our fellow men work for a living day by day to exist. It's an entirely different life, ruled by dire necessity. What I'm doing is really over the fringe of society; it's a luxury, not an essential commodity—except to me. And, among artists you have every shade from, let's say, my kind of work with a message to, let's say, Mark Rothko, who painted squares of color in juxtaposition to each other.

In Graham Greene's recent volume of memoirs, he says he's never understood how people who don't paint or create something manage to keep their sanity. You've said that your work is for you what therapy is for others.

I read of an actor recently who said that life is so absurd that the only way of coping is by working continuously so

64

you forget how absurd it is. There's something to it. It sounds simplistic. But perhaps that is my motivation for creating works like "In Praise of Folly" by Erasmus, or my "Fables with a Twist." I have to work day by day to justify my existence. I think that's the first motivation. And the second is, I'm always curious to see how the next thing is going to come out. When I look at some of my early cartoons, they lack the punch. And, as I grow older, I always hope from work to work that I have grown up. And maybe, Lord help me, I'm still growing.

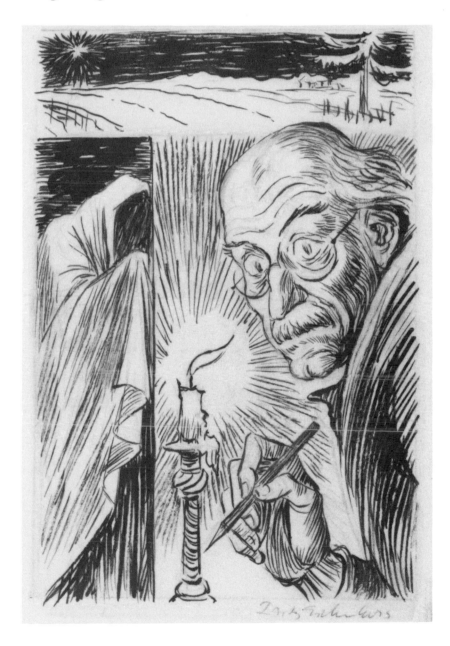

WHERE DO WE GO ?
(*1940*)

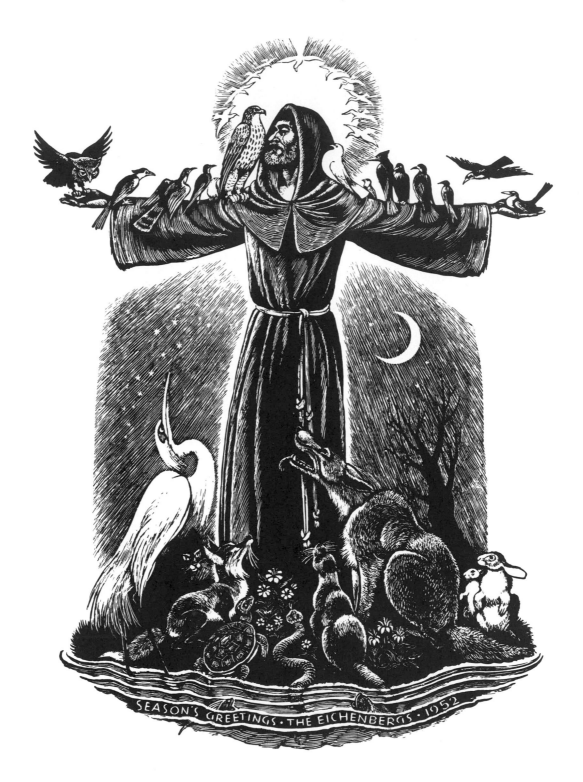

ST. FRANCIS, SERMON TO THE BIRDS (*1952*)

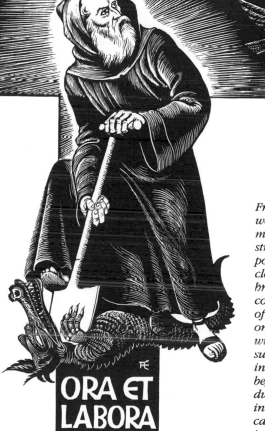

ST. BENEDICT (1953)

After the final fall of Rome when marauding bands swept unchecked through previously "secured" and "pacified" regions, the counter-values of the Christians emerged and began to take flesh in society. The most obvious carriers of these values were bands of monks who set themselves down by rivers and streams and made a promise of stability, a vow to spend their lifetimes in their communities. The motto of these men, followers of Benedict of Nursia, was of course Pax, and their ideal that work was prayer.

EILEEN EGAN

Francis did not preach against the wealth accumulated by the monasteries and by Rome itself. He stripped himself of all his possessions, including his rich clothing, and earned his daily bread through whatever work he could find. Failing to find any job of work, he begged for his food. On one occasion, he arrived to dine with a cardinal to find himself surrounded by knights and nobles in brocades and silks. Francis had begged bread on the way, and during the meal broke this bread into pieces and gave a piece to the cardinal and to each of the important guests. After the meal, the cardinal told Francis that this conduct had embarrassed him. Francis did not argue but explained, "The bread of charity is holy bread which the praise and the love of the Lord God sanctifies."

EILEEN EGAN

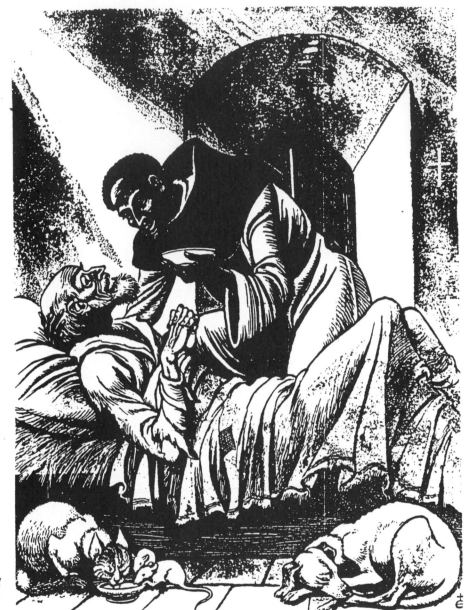

The saints are those who knew how to love, whose lives were transformed by love. The desire deep in the heart of every one of us is to love, to love in such a way that all things become new, that there is a new song in our hearts. The Church speaks of some as "blessed" or beatified, such as Martin de Porres, the Negro lay brother whose picture appears on this page. He is a South American saint, born in 1579 of a white father and a Negro mother in Peru and he was one who saw evil in all its horror of greed and lust and yet could love the sinner, and want to minister to him.

The saints were in such harmony with all created things that the very animals loved them and loved to be with them. They shed around them an aura of love because they had put off the old man and put on Christ.

DOROTHY DAY (1955)

BLESSED MARTIN DE PORRES (*1955*)

68

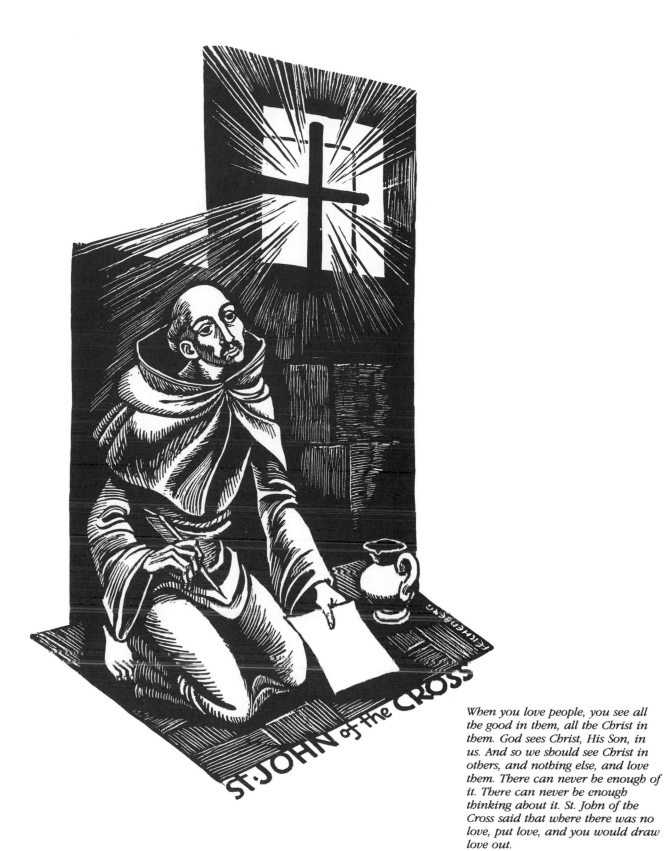

ST. JOHN of the CROSS

ST. JOHN OF THE CROSS (*1952*)

When you love people, you see all the good in them, all the Christ in them. God sees Christ, His Son, in us. And so we should see Christ in others, and nothing else, and love them. There can never be enough of it. There can never be enough thinking about it. St. John of the Cross said that where there was no love, put love, and you would draw love out.

DOROTHY DAY (1948)

St. Francis was "the little poor man" and none was more joyful than he; yet Francis began with tears, with fear and trembling, hiding in a cave from his irate father. He had expropriated some of his father's goods (which he considered his rightful inheritance) in order to repair a church and rectory where he meant to live. It was only later that he came to love Lady Poverty. He took it little by little; it seemed to grow on him. Perhaps kissing the leper was the great step that freed him not only from fastidiousness and a fear of disease, but from attachment to worldly goods as well.

Sometimes it takes but one step. We would like to think so. And yet the older I get, the more I see that life is made up of many steps and they are very small affairs, not giant strides. I have "kissed a leper," not once but twice—consciously—and I cannot say I am much the better for it.

DOROTHY DAY (1953)

We confess to being fools and wish that we were more so . . . What we would like to do is change the world—make it a little simpler for people to feed, clothe, and shelter themselves as God intended them to do. And to a certain extent, by fighting for better conditions, by crying out unceasingly for the rights of the workers, of the poor, of the destitute, we can to a certain extent change the world; we can work for the oasis, the little cell of joy and peace in a harried world. We can throw our pebble in the pond and be confident that its ever-widening circle will reach around the world.

We repeat, there is nothing that we can do but love, and dear God— please enlarge our hearts to love each other, to love our neighbor, to love our enemy as well as our friend.

DOROTHY DAY (1946)

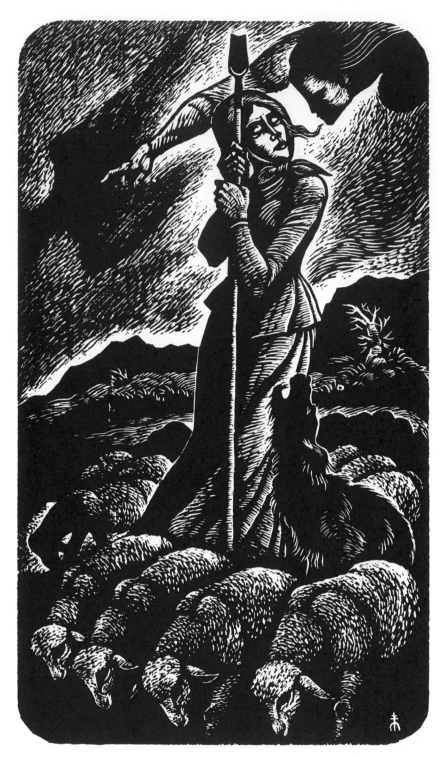

ST. JOAN OF ARC (*1964*)

70

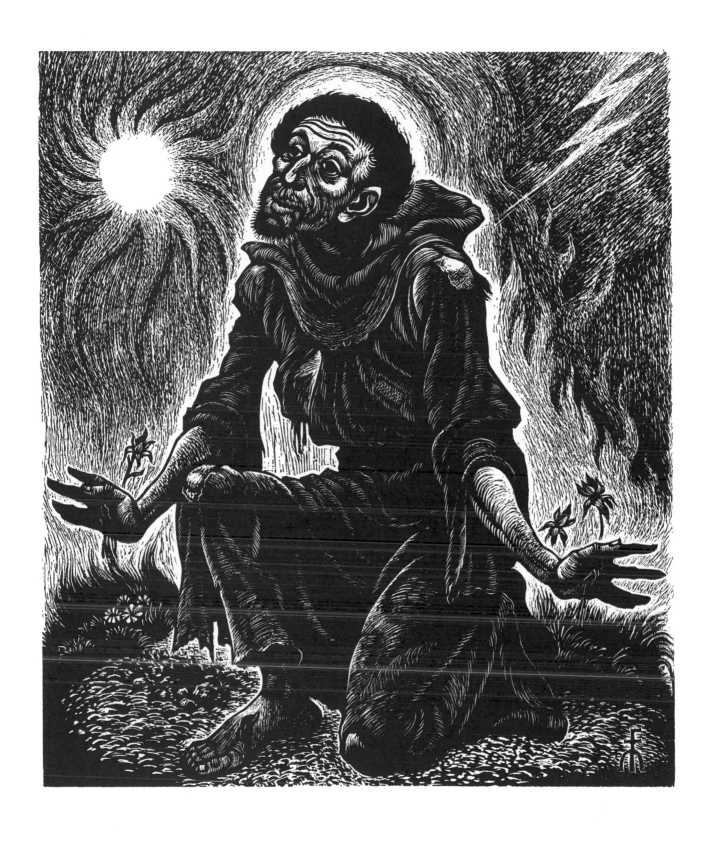

ST. FRANCIS, RECEIVING THE STIGMATA (*1973*)

There are many causes for the failure to comprehend Christ's teaching . . . but the chief cause which has engendered all these misconceptions is this, that Christ's teaching is considered to be such as can be accepted, or not, without changing one's life.

LEO TOLSTOY

Let us look at the past ten years. What land and sea did not witness warfare? What region was not soaked in Christian blood? The cruelty of Christians surpasses that of pagans and beasts. Christians attack Christians with the very weapons of Hell. Remember the battles fought during the last ten years? You will find that they were fought for causes that did not concern the common man. In most wars the safety of the heads of government is assured and the generals stand to gain. It is the poor farmer and the common people who bear the brunt of the destruction . . . There are times when peace must be purchased. Considering the tremendous destruction of men and property, it is cheap at any price. We must look for peace by purging the very sources of war—false ambitions and evil desires. As long as individuals serve their own personal interests the common good will suffer. Let them examine the self-evident fact that this world of ours is the Fatherland of the entire human race.

DESIDERIUS ERASMUS (1517)

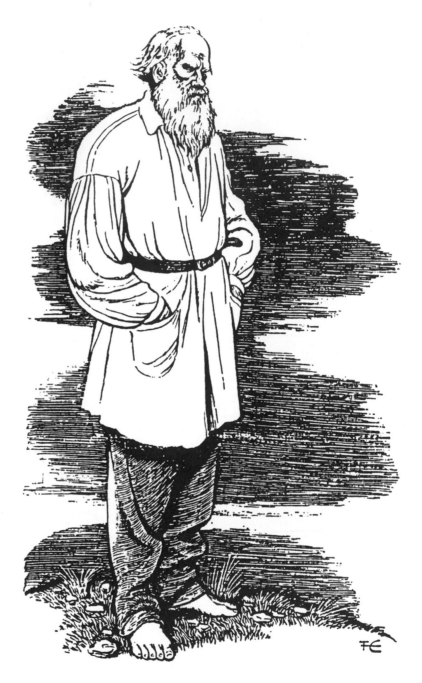

Count Leo Tolstoy

COUNT LEO TOLSTOY (*1960*)

72

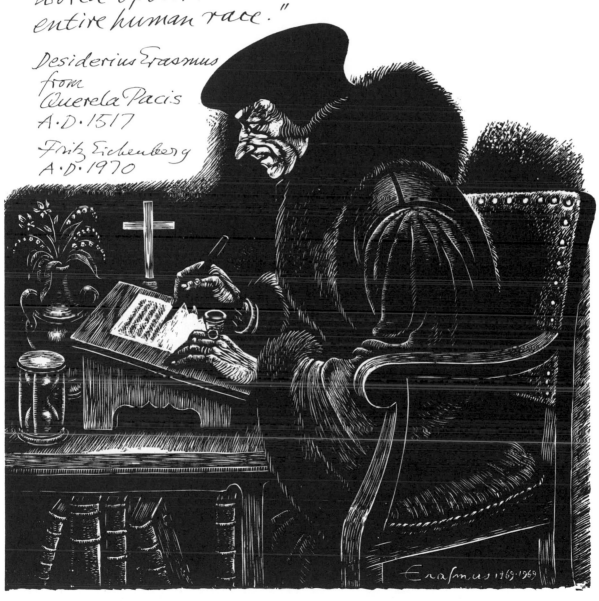

The Complaint of Peace

"We must look for peace by purging the
very sources of war — false ambitions
and evil desires. As long as individuals
serve their own personal interests, the
common good will suffer. Let them
examine the self-evident fact that this
world of ours is the Fatherland of the
entire human race."

Desiderius Erasmus
from
Querela Pacis
A·D·1517

Fritz Eichenberg
A·D·1970

ERASMUS, THE COMPLAINT OF PEACE (1970)

Love is the responsibility of an I for a you. In this lies the likeness of all who love . . . from the blessedly protected man, whose life is rounded in that of a loved being, to him who is all his life nailed to the cross of the world, and who ventures to bring himself to the dreadful point, to love all men.

MARTIN BUBER

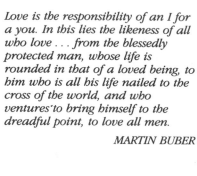

Whenever you are in doubt, or when the self becomes too much with you, try the following expedient:
Recall the face of the poorest and the most helpless man whom you may have seen and ask yourself if the step you contemplate is going to be of any use to him. Will he be able to gain anything by it? Will it restore him to a control over his own life and destiny? In other words, will it lead to the swaraj *or self-rule for the hungry and the spiritually starved millions of our fellow men?*
Then you will find your doubts and your self melting away.

MOHANDAS K. GANDHI

MARTIN BUBER (1978)

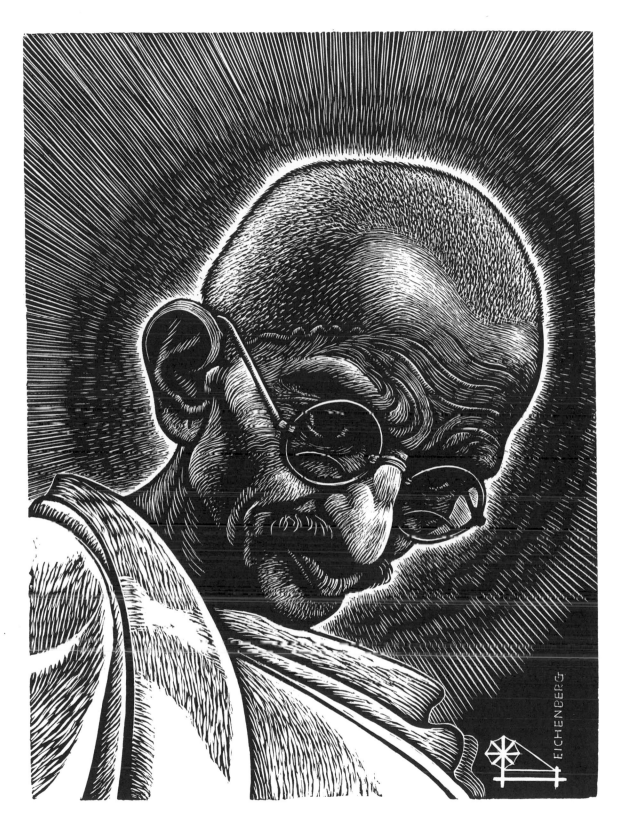

MOHANDAS GANDHI, GREAT SOUL (*1942*)

Peter was the poor man of his day. He was another St. Francis of modern times. He was used to poverty as a peasant is used to rough living, poor food, hard bed or no bed at all, dirt, fatigue, and hard and unrespected work. He was a man with a mission, a vision, an apostolate. But he had put off from himself honors, prestige, recognition. He was truly humble of heart, and loving. Never a word of detraction passed his lips, and as St. James said, the man who governs his tongue is a perfect man. He was impersonal in his love in that he loved all, saw all others around him as God saw them. In other words, he saw Christ in them.

He never spoke idle words, though he was a great teacher who talked for hours on end, till late in the night and early morning. He roamed the streets and the countryside and talked to all who would listen. But when his great brain failed, he became silent.

DOROTHY DAY

Co-founder of the Catholic Worker movement, she dedicated her life to the care of the insulted and injured.
She saw the hungry and the thirsty and she gave them food and drink.
She saw the lame and the blind and she helped them to walk and to see.
She saw the outcast, the despised, the defenseless, and she made them feel wanted and dignified.
She made the powerful and self-important aware of the plight of the untouchables, the outcasts of society.
A former radical and communist, a brilliant writer, and friend of the great intellectuals of her day, she turned to the faith of the Roman Catholic Church and remained true to it in all her works of mercy. She fought for the poor and suffered jail and persecution for their sake, a Fool for Christ, as she expressed it.

FRITZ EICHENBERG

76

PETER MAURIN (*1953*)

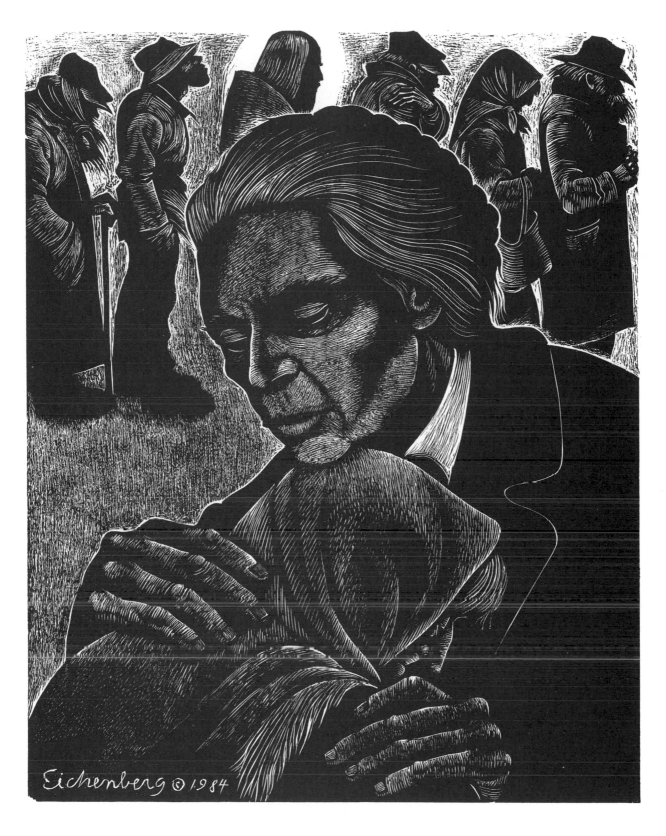

DOROTHY DAY *from* HOMAGE TO DOROTHY DAY (*1984*)

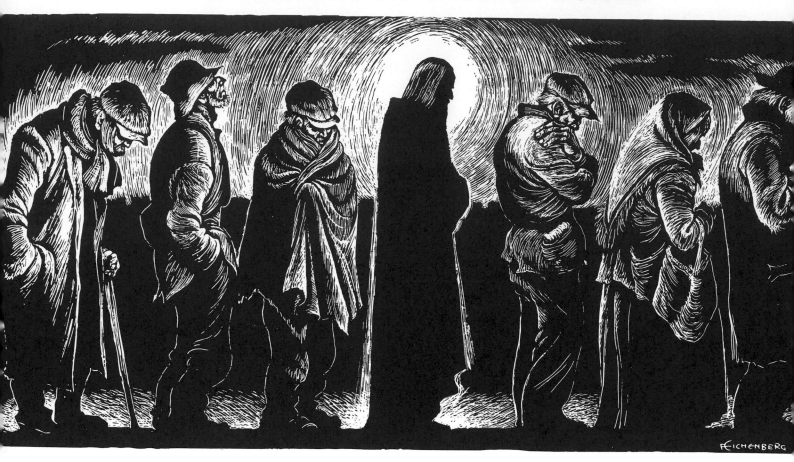

CHRIST OF THE BREADLINES (*1953*)

Homage to Dorothy Day

by Fritz Eichenberg

I met Dorothy Day in 1949, the year I had finished *The Brothers Karamazov.* How grateful I am to fate which put me next to her at a Quaker Conference on "Religion and Publishing" at Pendle Hill, the study center near Philadelphia. Of course I knew of her and her paper: a penny sheet of Christian radicalism, circulation close to one hundred thousand (still sold for a penny fifty years later, in 1983, another year of nonstop inflation).

She looked at me wistfully out of her slanted eyes, braids forming a halo around her head. She was clearly made of the stuff of saints and martyrs, although no one realized it then. You couldn't possibly refuse her anything without feeling ashamed of yourself. She must have known of my work through Dostoyevsky whom we both revered. She loved art; I loved her faith and courage.

"Would you be willing to do some work for our paper?" she asked with her bewitching smile. "You know we can't pay." I felt I had been knighted—and hooked! Did she know that I was not a Catholic, just a recently "convinced" Friend? Yes, she knew and that didn't bother her a bit. This was the beginning of our friendship which lasted for thirty years—and beyond—and is carried over in the young crew who continue valiantly in Dorothy's spirit to this day—and I hope beyond.

In 1949 my first contribution appeared in *The Catholic Worker*. There has hardly been an issue without some of my work in it, sometimes on a subject dear to her which I did on request, sometimes some print or drawing from some of my books related to her concerns. "Some of our readers can't read," Dorothy used to say, "but they understand your pictures—and save them."

I'll never forget my first visit to Mott Street in Manhattan's Chinatown, the Worker's first house of hospitality, where I saw with a shock my first breadline, where I gave my first talk in the eerily lit courtyard before a motley crowd of intellectuals and derelicts.

One couldn't help loving Dorothy. Her laughter was something I liked to provoke. Her love of art, music, literature was passionate, a love that lifted her out of the day-by-day sacrificial and self-ordained vocation of living with the poor, the rejected, the lacerated, the untouchables.

She never became a Salvation Army character, a woman in uniform. She treated the steady procession of human discards not as her subjects but as her equals. She had sown her wild oats and they had flowered and borne fruit. She had known love freely given; borne a child, which was one of the main reasons to seek the shelter of the Church, for both of them. She had given up the man she loved, the father of her child, who had stood in the way of her holy desire to seek grace and faith.

She never tried to convert me—nor anyone else as far as I know. She recognized and respected in me the free spirit which could not subscribe to any dogmatic approach to religion. We left it at that. She was an even freer spirit within the dogma which to her was a severe discipline, often a torture and self-laceration which she needed. There was a wildness

How can I help but think of these things every time I sit down at Chrystie Street or Peter Maurin Farm and look around at the tables filled with the unutterably poor who are going through their long-continuing crucifixion. It is most surely an exercise of faith for us to see Christ in each other. But it is through such exercise that we grow and the joy of our vocation assures us we are on the right path. The mystery of the poor is this: That they are Jesus, and what you do for them you do for Him. It is the only way we have of knowing and believing in our love. The mystery of poverty is that by sharing in it, making ourselves poor in giving to others, we increase our knowledge of and belief in love.

DOROTHY DAY (1964)

We often hear of Jesus of Nazareth as a wandering teacher; and there is a vital truth in that view so far as it emphasizes an attitude towards luxury and convention which most respectable people would regard as that of a vagabond . . . It is well to speak of his wanderings in this sense that he shared the drifting life of the most homeless and the most hopeless of the poor. It is assuredly well to remember that he would quite certainly have been moved on by the police and almost certainly arrested by the police, for having no visible means of subsistence. For our law has in it a turn of humor or touch of fancy which Nero or Herod never happened to think of: that of actually punishing homeless people for not sleeping at home.

G. K. CHESTERTON

in her spirit which was a joy to behold, but she had to tame it in her daily life with the poor, the dispossessed, the vengeful who surrounded her—tormented her too often. The Church and its daily spiritual exercises gave her strength and discipline.

She attracted the high and the low: the princes of the Church, the intellectuals, the famous; and the failures, the drop-outs, the non-stop talkers who never got anywhere. She did not suffer fools easily but she always forgave the poor, the meek in spirit, the rejected to whom no one else listened.

She gave me a little worn book, *The Lives of the Saints*, which I studied whenever a Saint's Day came around that she wanted to celebrate in the paper in a special way. "Could you do a St. So-and-So . . . ?" and I did—with joy in my heart because it pleased her and her readers.

I learned humility from her, among other virtues, although she so greatly admired my work that it could have turned my head. I considered my contributions truly humble compared to her own constant battle against life's inequalities, iniquities, violence. I followed her to the doors of prison—not further, coward that I am—when she demonstrated at Battery Place against Rockefeller's air-raid-shelter follies. I followed her to the courtroom, saw and heard her and her co-workers sentenced to jail—my heart pounding with indignation—and did a drawing of it for *The Catholic Worker* to redeem myself.

Her sense of humor carried her through myriad daily crises. She was often haunted by the city authorities, accused of violating housing regulations. The homeless were often sleeping in the corridors, since she wouldn't reject anyone. I saw her once taking an eviction notice which had just been delivered to her and jamming it over the head of a plaster St. Joseph standing on the mantel in the office. "You take care of it," she said in exasperation—and St. Joseph did.

There were always saints to help her out, and friends-in-need. At one critical time Dorothy lacked some twenty-five thousand dollars—a fantastic, unreachable sum—to install fire escapes and iron doors in St. Joseph's House. W. H. Auden, a friend, invited her to a TV interview and gave her a chance to make a plea for support. She got her twenty-five thousand dollars right away!

Over the years I attended many of the Friday night talks,

from Mott Street to Chrystie Street to First Street, and met an array of extraordinary men—Father D'Arcy from England, Abbé Pierre from France, Auden and Frank Sheed—with the obligatory sassafras tea afterwards. I never forgot my first talk in the backyard of Mott Street—a carré of tenements with people hanging out of windows on a hot summer night shouting at each other—a table with a flickering lantern, laundry hanging limply from washlines, assorted chairs for people who didn't want to sit on the floor—a Bertolt Brecht stage-set in the raw. I don't remember what I talked about—it must have been about art. There were plenty of interruptions as always on those Friday nights.

There were always people, sane or demented, who felt compelled to air their grievances—having a captive audience and an indulgent Dorothy Day sitting by. She was perhaps fuming inside, but never showing partiality. Let them talk, they belong to our family! Certain slide talks I gave later— "The Drama of the Human Face"—she could hear over and over and over again. It was to her the human pilgrimage, the Via Dolorosa which we all have to trudge—and how it's reflected on humanity's faces, from the first cry to the last of the crucifixion.

Our compassionate hearts met over Tolstoy and Dostoyevsky, whom we both loved with equal fervor. The books I gave her (with my illustrations) she cherished. They always mysteriously disappeared from her room. "Please inscribe them to me," she said, which didn't prevent anyone from considering her belongings common property. Her vows of poverty, chastity, obedience were taken to mean literally that she could not own anything—it had to be shared.

She had entered my life in so many ways and enriched it. When a failing marriage brought me to the brink of a breakdown, she gave me "absolution." Referring to Brecht's *Der Kreidekreis*, she asked me to draw a magic circle of chalk around me that would preserve my God-given identity—and sanity! When I intended to marry again she quoted the Bible, "It's not right for man to live alone."

When I attended a memorial Mass for her in 1980 at St. Patrick's Cathedral I missed her presence among all the gilded pomp and circumstance—I truly could not find her there. She is in the living hearts of the poor, of her friends

who loved her. I would prefer for her the little humble church around the corner where the poor, her friends, could pass her coffin. And now she rests on her plot on Staten Island, where she spent many happy hours.

It's trivial to say one misses her—she has remained in all of us who loved her.

So much has been written about Dorothy but nothing reflects her presence better than her autobiography, *The Long Loneliness*, published in 1952, for which she asked me to do some engravings. That she loved my work is one of the great rewards I received in my long career as an artist.

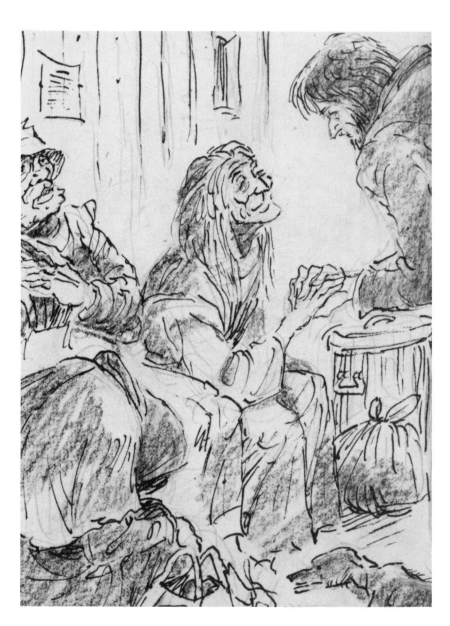

"All the way to heaven is heaven, because Christ said, 'I am the Way.'" And work should be part of heaven, not part of hell . . . In the black underground caverns where the miners lose all light of day— month after month, from early fall 'til late spring—there is a glimpse of "everlasting night where no order is and everlasting horror dwelleth." We want to change man's work; we want to make people question their work; is it on the way to heaven or hell?

Man gains his bread by his work. It is his bread and wine. It is his life. We cannot emphasize the importance of it enough. We must emphasize the holiness of work.

DOROTHY DAY (1946)

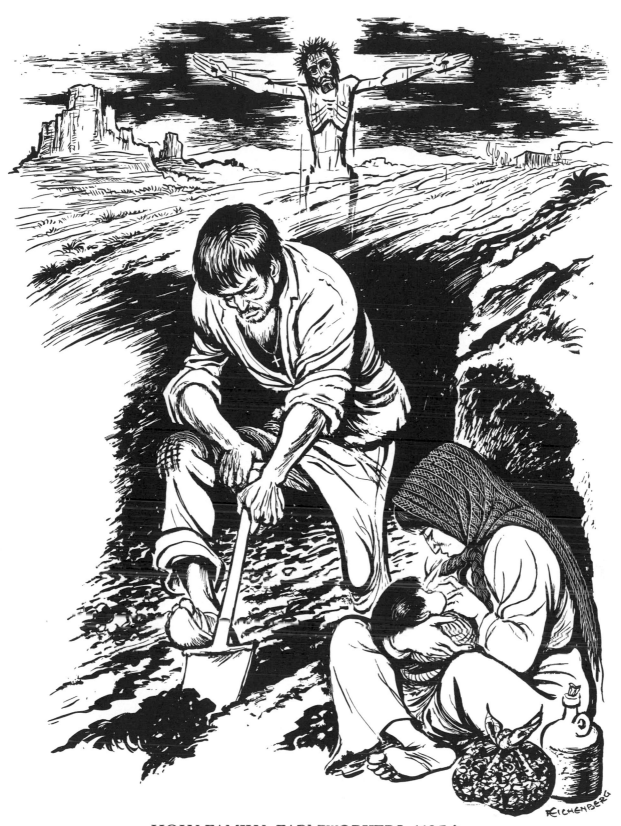

HOLY FAMILY, FARMWORKERS (*1954*)

We must practice the presence of God. He said that when two or three are gathered together, there He is in the midst of them. He is with us in our kitchens, at our tables, on our breadlines, with our visitors, on our farms. When we pray for our material needs, it brings us close to His humanity. He, too, needed food and shelter. He, too, warmed His hands at a fire and lay down in a boat to sleep. When we have spiritual reading at meals, when we have the rosary at night, when we have study groups, forums, when we go out to distribute literature at meetings, or sell it on street corners, Christ is there with us. What we do is very little. But it is like the little boy with a few loaves and fishes. Christ took that little and increased it. He will do the rest. What we do is so little we may seem to be constantly failing. But so did He fail. He met with apparent failure on the Cross. But unless the seed fall into the earth and die, there is no harvest. And why must we see results? Our work is to sow. Another generation will be reaping the harvest.

DOROTHY DAY (1940)

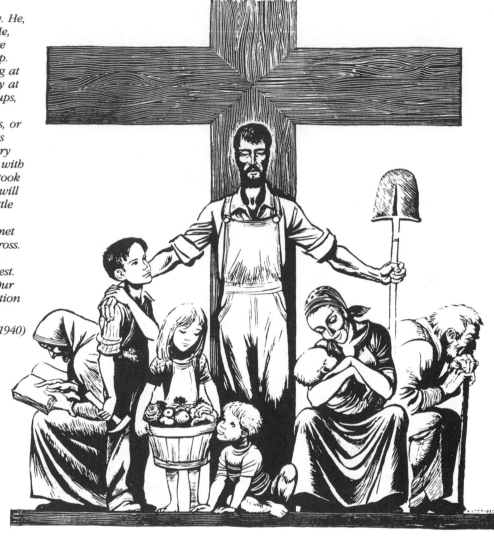

We cannot love God unless we love each other. We know Him in the breaking of bread, and we know each other in the breaking of bread, and we are not alone anymore. Heaven is a banquet and life is a banquet, too, even with a crust, where there is companionship.
We have all known the long loneliness and we have learned that the only solution is love and that loves comes with community.

DOROTHY DAY

CATHOLIC WORKER FAMILY (*1955*)

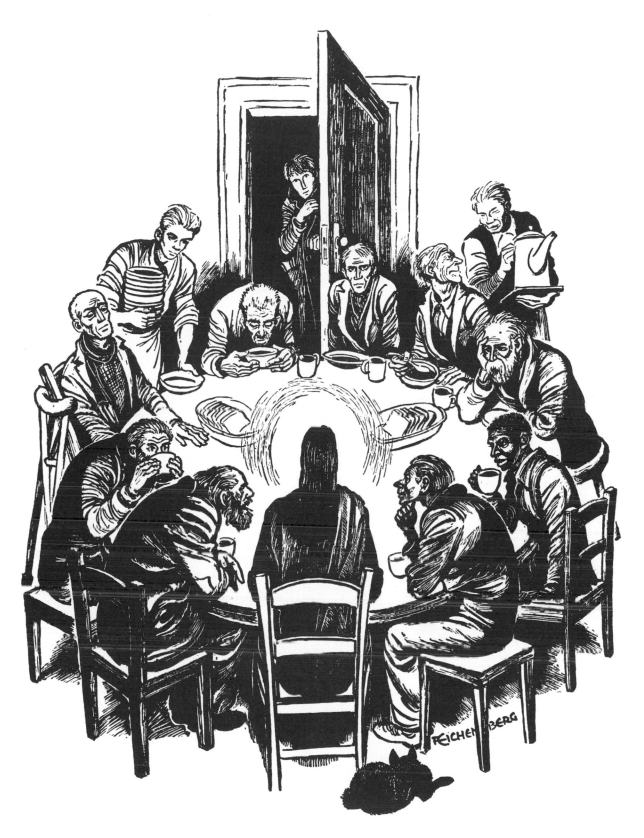

THE LORD'S SUPPER (1953)

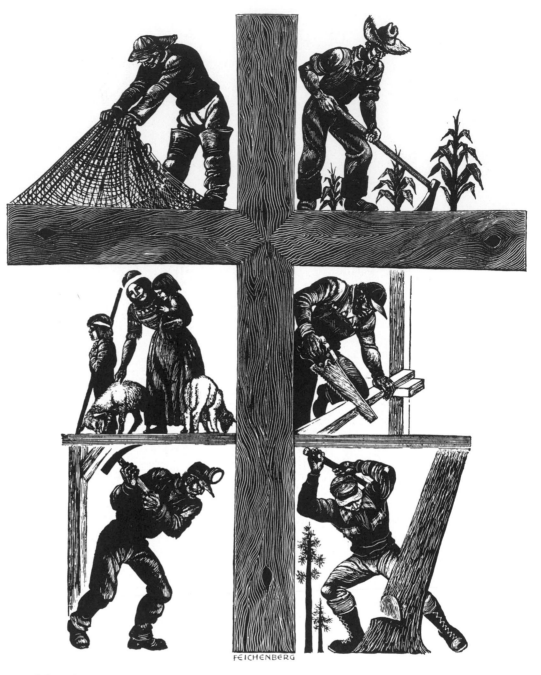

FEICHENBERG

Peter Maurin's Christian philosophy
of work was this. God is our
creator. God made us in His image
and likeness. Therefore we are
creators. He gave us a garden to
till and cultivate. We become co-
creators by our responsible acts,
whether in bringing forth children,
or producing food, furniture or
clothing. The joy of creativeness
should be ours.

DOROTHY DAY (1952)

THE LABOR CROSS (*1952*)

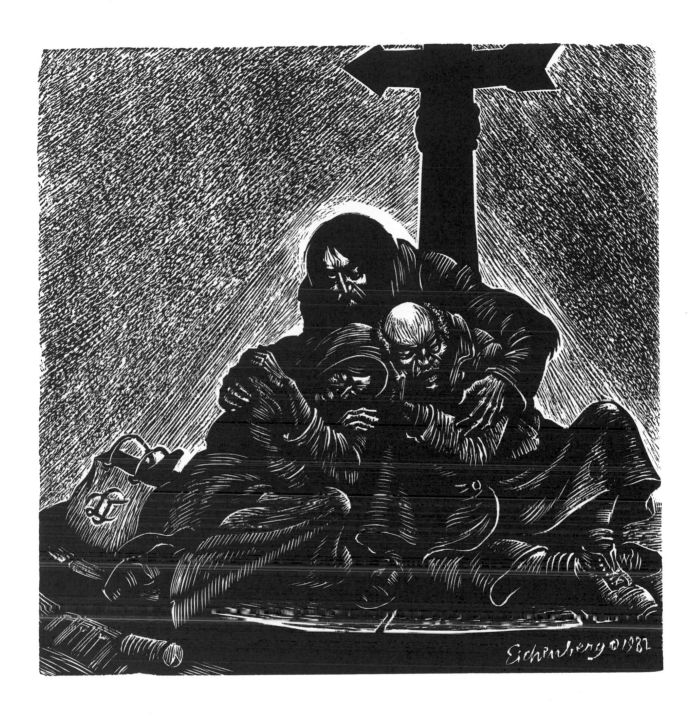

CHRIST OF THE HOMELESS (*1982*)

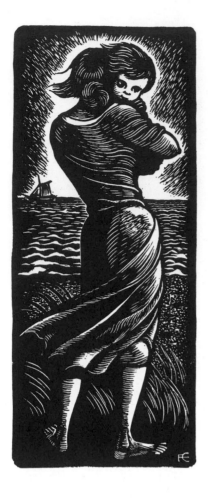

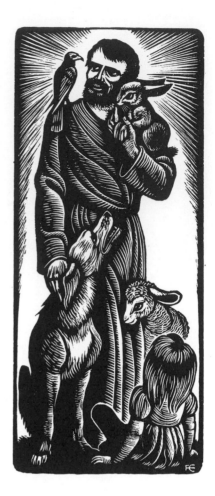

I had been passing through some years of fret and strife, beauty and ugliness—even some weeks of sadness and despair. There had been periods of intense joy but seldom had there been the quiet beauty and happiness I had now. I had thought all those years that I had freedom, but now I felt that I had never known real freedom nor even had knowledge of what freedom meant.

Now, just as in my childhoood, I was enchained, tied to one spot . . . I was tied down because I was going to have a baby. No matter how much I might sometimes wish to flee from my existence, I could not, nor would I be able to for several years. I had to accept my quiet and stillness, and accepting it, I rejoiced in it . . .

I had known Forster a long time before we contracted our common-law relationship, and I have always felt that it was life with him that brought me natural happiness, that brought me to God.

His ardent love of creation brought me to the Creator of all things. But when I cried out to him, "How can there be no God when there are all these beautiful things," he turned from me uneasily and complained that I was never satisfied . . .

It was a peace, curiously enough, divided against itself. I was happy but my very happiness made me know that there was a greater happiness to be obtained from life than any I had ever known. I began to think, to weigh things, and it was at this time that I began consciously to pray more . . .

I speak of the misery of leaving one love. But there was another too, the life I had led in the radical movement . . . I was just as much against capitalism and imperialism as ever, and here I was going over to the opposition, because of course the Church was lined up with property, with the wealthy, with the state, with capitalism, with all the forces of reaction. This I had been taught to think and this I still think to a great extent . . . I loved the Church for Christ made visible. Not for itself, because it was so often a scandal to me . . .

I went to the national shrine at the Catholic University on the feast of the Immaculate Conception. There I offered up a special prayer, a prayer which came with tears and with anguish, that some way would open up for me to use what talents I possessed for my fellow workers, for the poor.

DOROTHY DAY
from The Long Loneliness

88

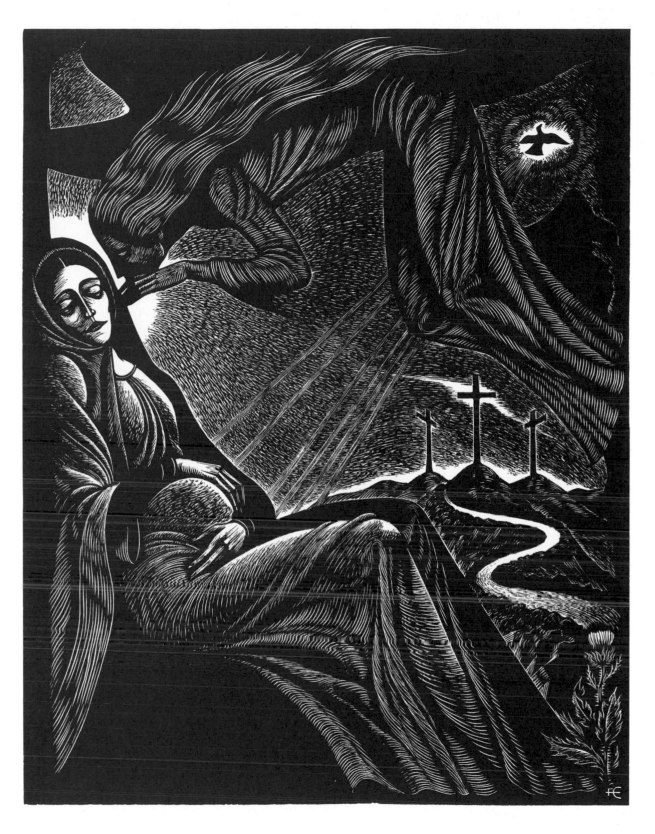

PRINTS *from* THE LONG LONELINESS by Dorothy Day (*1952*)

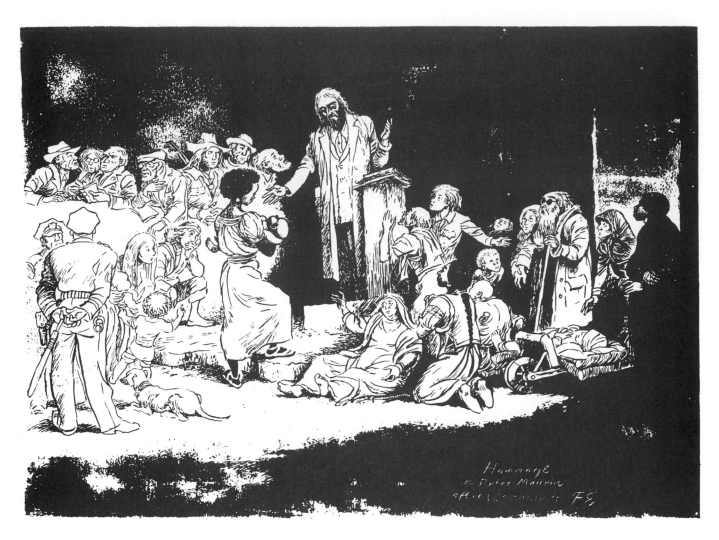

HOMAGE TO PETER MAURIN (*after Rembrandt, 1977*)

"We need to make the kind of society," Peter had said, "where it is easier for people to be good." And because his love of God made him love his neighbor, lay down his life indeed for his brother, he wanted to cry out against the evils of the day—the state, war, usury, the degradation of man, the loss of a philosophy of work. He sang the delights of poverty (he was not talking about destitution) as a means to making a step to the land, of getting back to the dear natural things of earth and sky, of home and children. He cried out against the machine because, as Pius XI had said, "raw materials went into the factory and came out ennobled and man went in and

came out degraded"; and because it deprived a man of what was as important as bread—his work, his work with his hands, his ability to use all of himself, which made him a whole man and a holy man . . . Peter had been insulted and misunderstood in his life as well as loved. He had been taken for a plumber and left to sit in the basement when he had been invited for dinner and an evening of conversation. He had been thrown out of a Knights of Columbus meeting. One pastor who invited him to speak demanded his money back which he had sent Peter for carfare to his upstate parish because, he said, we had sent him a Bowery bum, and not the speaker

he expected. "This then is perfect joy," Peter could say, quoting the words of St. Francis to Friar Leo. He was a man of sincerity and peace, and yet one letter came to us recently, accusing him of having a holier-than-thou attitude. Yes, Peter pointed out that it was a precept that we should love God with our whole heart and soul and mind and strength, and not just a counsel, and he taught us all what it meant to be children of God, and restored to us our sense of responsibility in a chaotic world. Yes, he was "holier than thou," holier than anyone we ever knew.

DOROTHY DAY (1949)

90

SCENES OF WAR AND PEACE

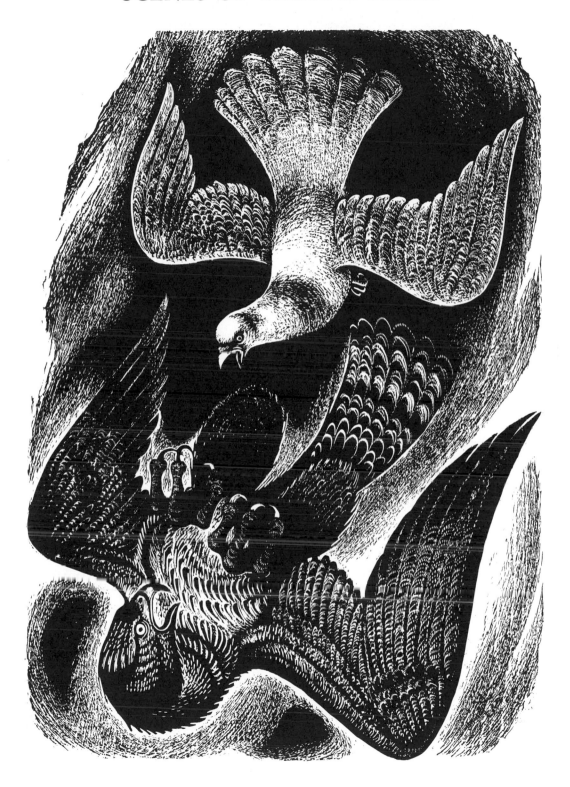

THE DOVE AND THE HAWK (*1969*)

Art
and
Faith

by Fritz Eichenberg

It is not exaggeration to say that our times are apocalyptic, in the sense that we seem to have come to a point at which all the hidden, mysterious dynamism of the "history of salvation" revealed in the Bible has flowered into final and decisive crisis. The term "end of the world" may or may not be one that we are capable of understanding. But at any rate we seem to be assisting at the unwrapping of the mysteriously vivid symbols of the last book of the New Testament. In their nakedness, they reveal to us our own selves as the men and women whose lot it is to live in the time of a possibly ultimate decision . . . We are challenged to prove we are rational, spiritual and humane enough to deserve survival, by acting according to the highest ethical and spiritual norms we know.

THOMAS MERTON

If the artist's work is his worship, if he earnestly desires to serve God and through Him, man, the artist will, in the end, achieve that peace of mind, that freedom of the soul, that mastery of matter which will bring him to the foot of the Cross. He will leave behind him egotism, which causes an artist to rotate around himself in constant self-reflection, deadened to the labors, joys and sufferings of his fellow men. Greed will have to go. Greed, which is hunger for the power that money can buy, for prestige and fame, a hunger that perpetuates itself and can never be satiated. Speed will have to be discarded. Speed, which kills the craftsman and his work, which spoils the enjoyments of nature, fills our senses, prevents meditation and the maturing of a growing mind . . .

The artist who succeeds in freeing himself from all these encumbrances will have to embrace poverty. One of the artist's biggest problems has always been to resist the pressure and influence of those who patronize him. To reduce his standard of living to bare necessities is his most effective means of independence.

In our world of growing tensions, in our civilization of fear and insecurity, it seems that voluntary poverty, as Christ and St. Francis and Gandhi knew it, is the only way to remove entirely from our lives the causes of strife and frictions. Like the apostles working with their hands to secure the necessities of life, sharing with those around them, physically and spiritually, the man of the spirit can maintain himself, his integrity and his independence . . .

The artist is the eternal fool, close to the child and close to God. His suffering is not a matter of choice; it is in the nature of all creating. The honor roll of the ordeals inflicted upon him by his fellow man is appallingly long.

"Freedom is a margin to move about, to try oneself out," says Peguy, "it is mind working on mind." That is the true artist's conception of his vocation. Seeing through the fabric of texture and flesh into the soul of things, sensing impending change, suffering with humanity, he is alone in his creative labors, and like most prophets, he must expect to be stoned and derided, silenced and neglected . . .

We must recapture what we have lost, we must fight for our faith, fight our way back to God. We must become cre-

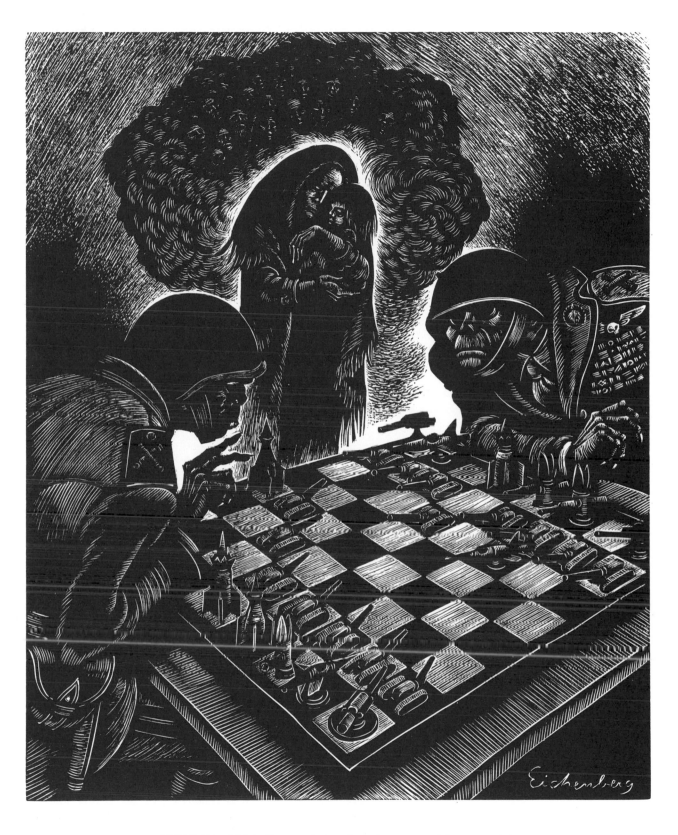

STALEMATE *from* DANCE OF DEATH (*1980*)

ative again, whole again, and aware of our responsibility as architects of a new moral order.

It is useless, if not criminal, to invade the universe with dazzling machines and with blank and immature minds.

The first command of civilized man is to create order out of chaos.

The artist, whatever his calling, must play his part, side by side with the scientist and the engineer, in enhancing the value of life and in adding meaning, joy and beauty to our existence on this—and, perhaps, on other planets.

Like so many other ancient cities of Europe, Cologne, founded fifty years after the birth of Christ, was reduced to rubble during the last war. Several hundred of the most beautiful churches in the world built by generations of devoted artisans, masons and laborers, were destroyed within a few short months. It so happened that five years after the end of the war, I met a young man, a devout Catholic, and a lover of the arts, who had dropped a few of those bombs on my old home town. "So sorry," he said, somewhat embarrassed, "but orders were orders." He is now a Trappist monk entered upon a life dedicated to God, work and silence.

Call it accident or atonement, we can't escape the command to be our brother's keeper. Our actions and follies are divinely and sometimes diabolically interwoven. The fragmentation and ugliness of modern warfare is undoubtedly reflected in many works of modern art. Life and Art cannot be separated. We are all responsible; we should be seriously concerned. Whatever the follies of modern art may be, we have helped to produce them; they are a mirror held before us. Let's face it. We have to mend our ways and try to bring order into chaos, piece the fragments together, become whole again, holy again.

We must go back to creative work and significant play, we must drop all empty substitutes, the adolescent thrills and games and gadgets which make us more lonely and more restless.

There is enough excitement in our daily tasks if we approach them reverently and creatively, no matter in what medium we work. Whether we work in the field of human relations, in stone or wood, with pen and paper, there is the thrill of fighting injustice, inequality, disease, of suffering for

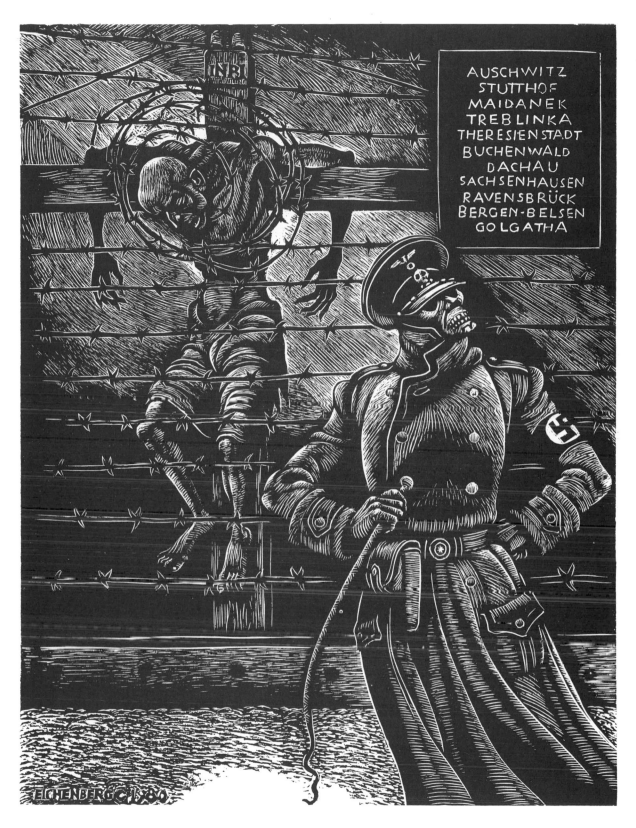

CRUCIFIXION *from* DANCE OF DEATH (*1980*)

Our community today is a gathering together of peacemakers. We pray that the God of peace may cleanse us in our will to war, that God may bestow on us some measure of wisdom and steadfastness in the tasks of peace. We gather, we pray together, and we disperse again, knowing that the work of peace cannot be accomplished in churches; it can only begin there. The making of peace implies the will to return to our world in love, to stand firm in public, to confront the powers and principalities, to assert in time of war that no government which makes war can govern well; that we ourselves will not submit before a governing hand that would thrust weapons into our hands and command us away from the paths of peace.

DANIEL BERRIGAN, S.J.

our convictions, of having the courage to stand up and be counted for all the despised and unpopular causes for which we feel called upon to fight.

We can delight in the realization of the brotherhood of all men without forgetting the soothing value of solitude, the necessity for meditation. We can experience the thrill of finding God close to us in the silence of the meeting house, of our workshop or out under the immensity of a starry sky.

The child, the poet, the fool and the saint—how close they are together in their longing for God. The artist is among them and he may be allowed to believe that men still prefer beauty and truth to ugliness and deception, blooming meadows to scorched earth, a Bach chorale to the screech of battle.

The artist wants to believe with all his heart that man still has a choice, that he does not want to destroy himself, but start a better breed, devoted to Faith, Hope and Charity.

From "Art and Faith," a Pendle Hill Pamphlet, 1952

What are we to do? The duty of the Christian in this crisis is to strive with all his power and intelligence, with his faith, hope in Christ, and love for God and man, to do the one task which God has imposed upon us in the world today. That task is to work for the total abolition of war . . .
At the root of all war is fear: not so much the fear men have of one another as the fear they have of everything. It is not merely that they do not trust one another: they do not even trust themselves. If they are not sure when someone else may turn around and kill them, they are still less sure when they may turn around and kill themselves. They cannot trust anything because they have ceased to believe in God.

THOMAS MERTON

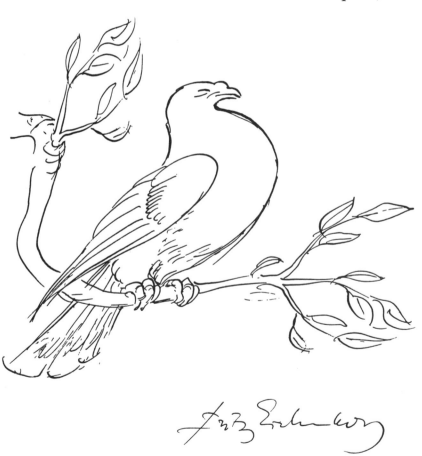

96

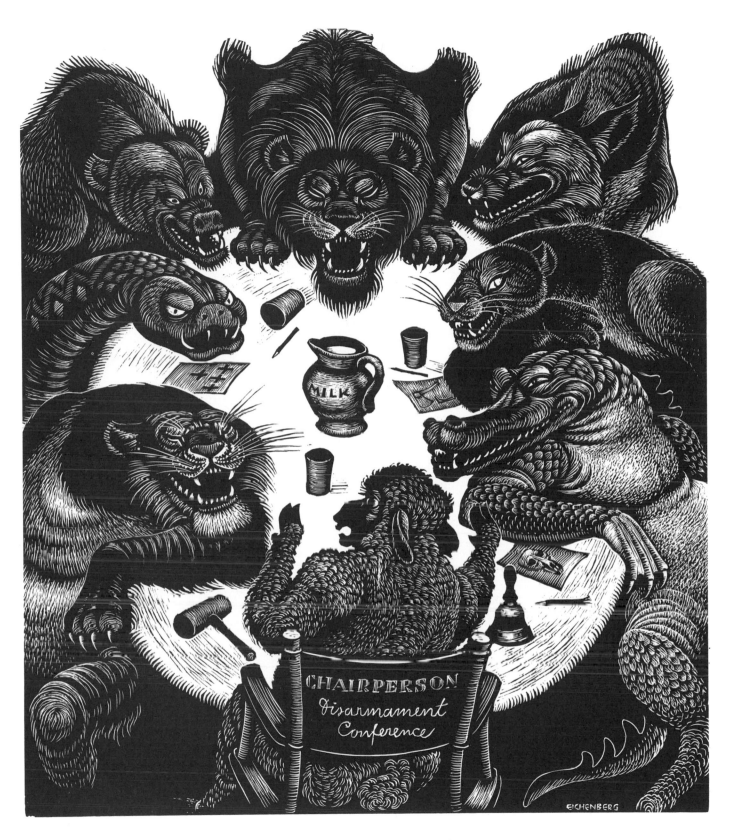

TOTAL DISARMAMENT *from* FABLES WITH A TWIST (*1980*)

Art
as
Witness

by Fritz Eichenberg

Our Savior came to save and not to destroy the lives of men; to give and plant peace among men; and if in any sense He may be said to send war, it is the Holy War indeed, for it is against the Devil, and not the persons of men. Of all His titles this seems the most glorious as well as comfortable for us, that He is the Prince of Peace. It is His nature, His office, His work, and the end and excellent blessing of His coming who is both the maker and preserver of our Peace with God. And it is remarkable that in all the New Testament He is but once called Lion, but frequently the Lamb of God, and that those who desire to be the disciples of His Cross and Kingdom, for they are inseparable, must be like Him as St. Paul, St. Peter, and St. John tell us. Nor is it said that the Lamb shall lie down with the Lion, but the Lion shall lie down with the Lamb. That is: War shall yield to Peace, and the soldier turn hermit.

WILLIAM PENN (1693)

Creativity is potentially dormant in every human mind. It needs nourishment and care. If we could only learn to approach everything we do with love, discover the secret of living harmoniously with nature, with our neighbor, our families, realize the joy of creating beauty in ourselves and around us, open our eyes to the grand design in all things living, we would be rewarded immeasurably.

Even if this does not make artists of all of us, it will bring us closer to the creative arts and their enjoyment on so many different levels, and enrich our lives.

There are so many forms creativity may take. If we conceive of it in terms of Michelangelo's *Last Judgment* or Picasso's *Guernica*, of *The Odyssey* or of Beethoven's *Pastorale*, we may soon come to the conclusion that our own puny efforts aren't worth the sleepless nights we spend on struggling with our obstreperous genius.

Many of our most desperate cravings for immortality die in childhood, shriveled up in a feeling of impotence and frustration from daring to measure our feeble efforts against the monumental achievements of those geniuses certified by history.

"Creation" is an awe-inspiring word. In conjures up the image of a mysterious power that can create light out of darkness, order out of chaos, devise a planetary system that rules life on this, our small planet.

Yet there is no reason to get disheartened. Our tentative activities in this giant mystery may set off the spark that lifts us out of our anonymity, provides the shot of adrenalin that energizes our minds, gives wings to our imagination, and may make us partners with the divine spirit that created our Universe.

Whatever our gifts—they will surely reach those around us, our friends, our children, our community of kindred spirits. That's where our efforts may stop—or they may spread— pebbles thrown into the water, making circles which may reach far shores and may set in motion momentous changes we can't foresee.

We all have special talents—gifts from Heaven often buried under the trivia of our daily routine. We refer to them as hobbies, occupational therapy, leisure hours, meditation. They may be the most valuable assets we have, if we use

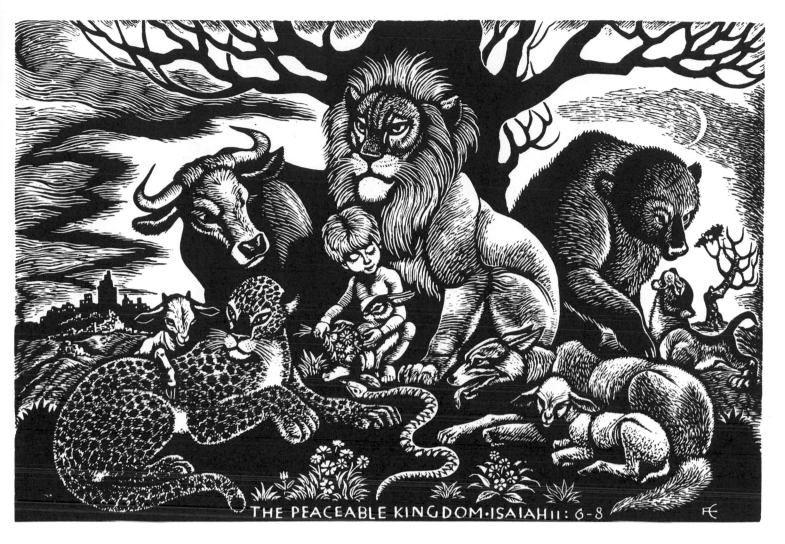

THE PEACEABLE KINGDOM (*1950*)

*For more than half a century, at
Christmas time, I have sent a print
to my friends everywhere, usually a
commentary on the state of the
world — and incidentally on my
own condition. There are many
ways of spreading our message of
peace, hope and faith among the
peoples of this earth. We are all
blessed with different gifts, witnesses
ready to be counted.
The debt we owe great art,
accumulated over the centuries, is
immeasurable. Let's try to pay it off
by listening to its immortal voice,
reviving our own creative spirit for
the sake of the Peaceable Kingdom.*

 FRITZ EICHENBERG, 1984

LORD,
MAKE ME AN INSTRUMENT
OF THY PEACE ·
WHERE THERE IS HATRED,
LET ME SOW LOVE;
WHERE THERE IS INJURY,
PARDON;
WHERE THERE IS DOUBT,
FAITH;
WHERE THERE IS DESPAIR,
HOPE;
WHERE THERE IS DARKNESS,
LIGHT;
WHERE THERE IS SADNESS,
JOY.
O DIVINE MASTER, GRANT
THAT I MAY NOT SO MUCH
SEEK TO BE CONSOLED
AS TO CONSOLE,
TO BE UNDERSTOOD ·
AS TO UNDERSTAND,
TO BE LOVED
AS TO LOVE;
FOR IT IS IN GIVING
THAT WE RECEIVE,
IT IS IN PARDONING
THAT WE ARE PARDONED,
AND IT IS IN DYING
THAT WE ARE BORN
TO ETERNAL LIFE · *St. Francis*

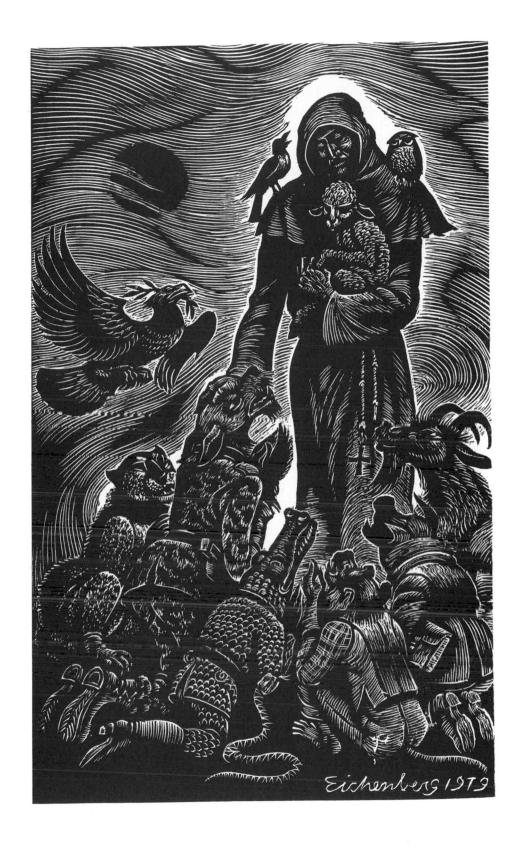

ST. FRANCIS (*1979*)

them in a constructive way, with love and deepening understanding of the world around us.

Alas, I can only speak with some semblance of authority about the visual arts. Artists are witnesses of their time. They reflect the events swirling around them. Their work is formed in the labors of giving birth—a mixed blessing of joy and suffering, of the ecstasy and agony of forging out of the artists' substance an image that mirrors their existence against the background of their time, our time.

All truly great art is universal, it belongs to the world. Its media are interchangeable. Paintings turn into plays, poetry into music, great thoughts and words into images. It's the creative genius that shines through and illuminates the work of the truly great no matter what their tools are—sound, movement, words, paint, or form.

Often we do enjoy greatness without recognizing it. Only when the genius has taken his leave do we realize with a shock how impoverished our lives would be without those great works we take too much for granted. What enormous debt we owe those great spirits. Inspired by them we become conscious of the obligation to use our talents in the context of the time in which we live.

To remain sensitive to the human problems surrounding us we will have to descend from our Ivory Towers into the street, perhaps onto the barricades and into a brush with the law. If you are not afflicted with a social conscience this may not be your idea of an artist's life. But if you are born with certain convictions, your path, no matter how thorny, is laid out for you and you have to follow, even if your tender feet object.

Two centuries ago our lone Quaker artist, Edward Hicks, painted his vision of the Peaceable Kingdom over and over again, against the advice of his own Meeting. He found no followers in his time.

Under the menace of humanity's possible annihilation by our own fiendish inventiveness, our spiritual shepherds in churches and temples have finally entered the public arena. They remind those who call themselves Christians to follow the Prince of Peace rather than the Devil of Destruction. The hour is late, and we need all the faith and hope we can muster.

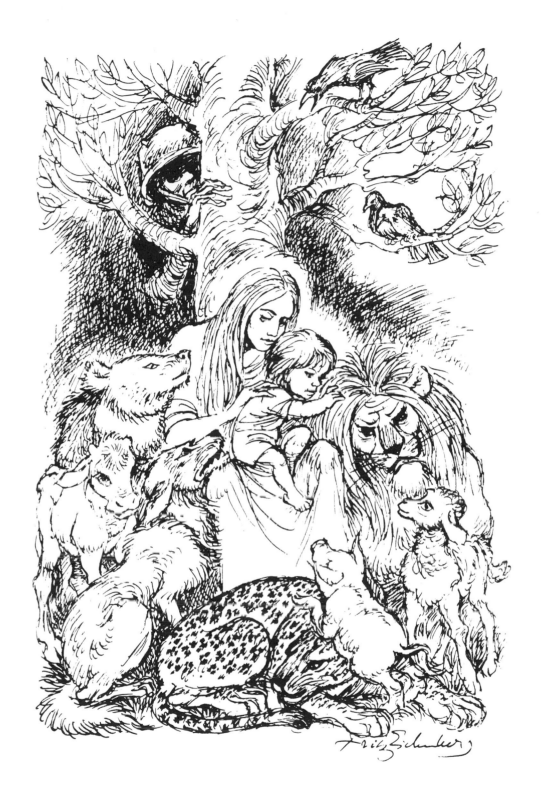

THE PEACEABLE KINGDOM (*1978*)

In this mounting surge of protest, art can play a powerful role. Religious leaders of all denominations are beginning to rise out of their lethargy and make use of art's spiritual power, on canvas, on paper, on stage and screen.

I am pleading for art with a conscience, for art as a witness, for using the gifts we have received by a higher dispensation for humanity's benefit.

At best the artist has always been considered God's Fool, and treated accordingly with condescension, indifference or neglect. No matter. Art has survived the cavemen, the Pharaohs, the princes and the popes; it will survive the computer—if we care enough.

An artist with a social conscience walks a thorny path. Sensitive to the illnesses of his time and giving expression to his concerns in any medium, he is bound to run up against the guardians of the status quo. Art is not a popularity contest nor is it apt to make you rich, as history records. Your conscience and the strength of your convictions must back you up.

I feel in myself the spirit of George Fox and John Woolman, the spirit which also inhabited great souls like Gandhi and Dorothy Day. Neither jail nor mistreatment would hold them back from their missions, living testimony that love would overcome hatred.

I felt honored that Dorothy Day wanted my work on the pages of *The Catholic Worker*, a true witness that Art and Faith can go together. I feel rewarded that my work has been used by so many denominations and groups devoted to peace in our time. I am happy that my work finds the intended target, the human heart.

For more than half a century, at Christmas time, I have sent a print to my friends everywhere, usually a commentary on the state of the world—and incidentally on my own condition. There are many ways of spreading our message of peace, hope and faith among the peoples of this earth. We are all blessed with different gifts, witnesses ready to be counted.

The debt we owe great art, accumulated over the centuries, is immeasurable. Let's try to pay it off by listening to its immortal voice, reviving our own creative spirit for the sake of the Peaceable Kingdom.

From "Artist on the Witness Stand,"
a Pendle Hill Pamphlet, 1984

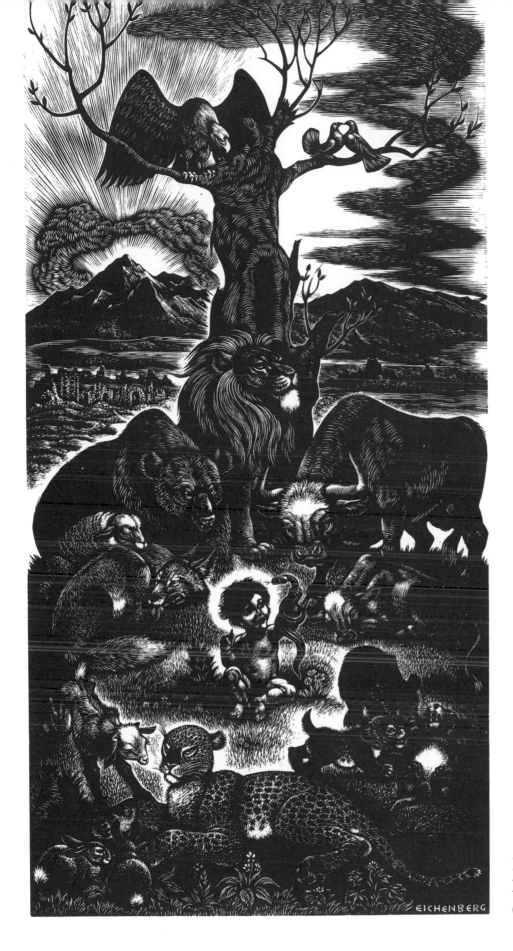

PEACEABLE
KINGDOM
(*1955*)

Midnight has fallen
and the woods are quiet.
Truce has been declared,
the hunt has stopped.
The eagle has his fill,
the gulls are resting,
and the fish
are safely sleeping in their pond.
The pigeon dreams of love,
the crow of sharing carrion
with the vulture.
The owl is wide awake.
The watchman of the night
must think of weightier things
than mice.
Pallas Athena's bird, with a degree
in wisdom, perches on a skull
and ponders what those eggs may yield:
New insights, a messiah,
or new horrors—
perhaps a neutron bomb?

Poem: NIGHTWATCH *from* FABLES WITH A TWIST

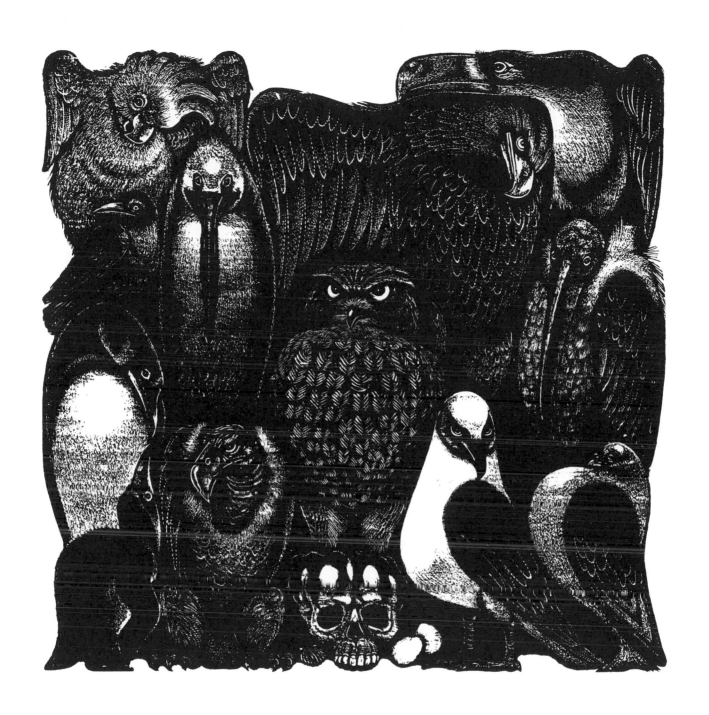

NIGHTWATCH (*1963*)

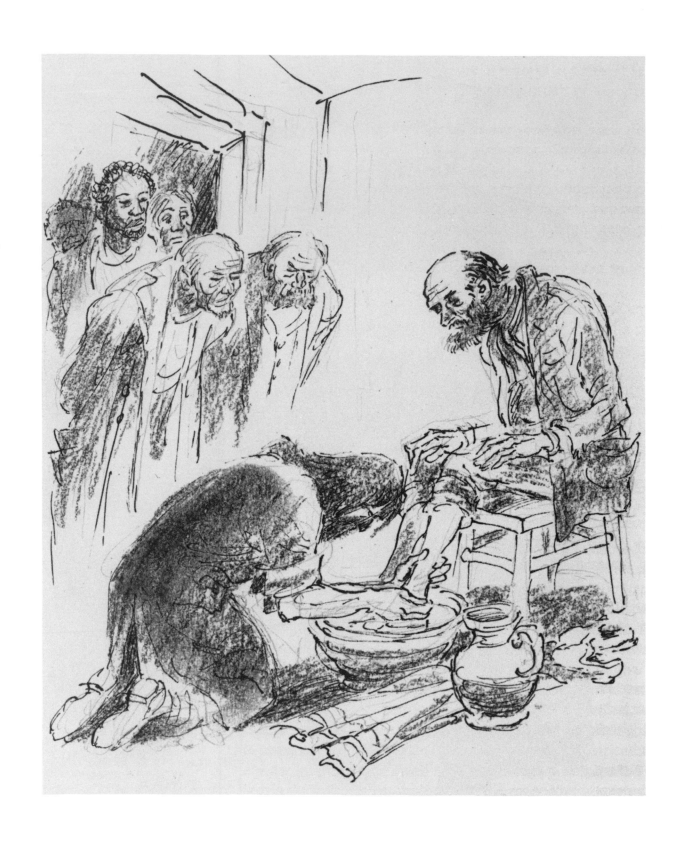

SERVANT OF ALL (*1985*)

THE DREAM OF REASON (*1976*)

FRITZ EICHENBERG, WORKS OF MERCY
The type was set in Garamond by ORBIS BOOKS, Maryknoll,
New York, and the paper was made at the Glatfelter papermill
in Spring Grove, Pennsylvania. The book was printed and bound
in Kingston Natural cloth, by Braun-Brumfield, Inc.,
at Ann Arbor, Michigan, in Fall of 1992.
Antonie Eichenberg designed this book.